Beardsley

Beardsley

Simon Wilson

Phaidon · Oxford

Phaidon Press Limited
Littlegate House, St Ebbe's Street
Oxford, OX1 1SQ

First published 1976
This edition, revised and enlarged,
first published 1983
© Phaidon Press 1983

British Library Cataloguing in Publication Data
Wilson, Simon
 Aubrey Beardsley. — New ed. — (Phaidon colour
 library)
 1. Beardsley, Aubrey
 I. Title II. Beardsley, Aubrey
 741.942 NC242.B3

 ISBN 0–7148–2264–7
 ISBN 0–7148–2265–5 Pbk

Printed in Great Britain by
Balding + Mansell Limited, London and Wisbech

Acknowledgements

It is impossible to write about Beardsley's art without
constant recourse to Brian Reade's pioneering work
on the subject, particularly his great monograph
Beardsley (London 1967) which remains the only
substantial survey of Beardsley's art. On the bio-
graphical side equally indispensable is *The Letters of
Aubrey Beardsley* edited in 1968 by Messrs. Maas,
Duncan and Good. Stanley Weintraub's biography,
first published in 1967, enlarged and expanded in
1976, is unlikely to be superseded. A new biography
by Miriam Benkovitz appeared in 1982. Among shorter
biographical and critical studies those by Brigid
Brophy are full of facts and insights which have con-
tributed outstandingly to the understanding of
Beardsley.

I should like to thank all the public and private
owners who have given permission for works in their
possession to be reproduced, and Cassell and
Company where Mary Griffith was very helpful in
arranging the loan of certain photographs. I should
also like to thank my old friend Robert M. Booth for
his encouragement and help, including the loan of the
beautiful and rare books from his collection. Finally,
thanks to Peg Katritzky at Phaidon Press for her
dedication in obtaining the new photographs re-
quired and, not least, to Wendy Ciriello at the Tate
Gallery who typed the manuscript in her spare time
for love of Beardsley.

Simon Wilson

Aubrey Beardsley
21 August 1872 – 16 March 1898

'The appearance of Aubrey Beardsley in 1893 was the most extraordinary event in English art since the appearance of William Blake a little more than a hundred years earlier.' Thus wrote Holbrook Jackson in *The Eighteen Nineties*, a pioneering study, first published in 1913, of a decade in the history of English art and literature that even before it was over was seen as having a very special quality of its own, as constituting a distinct historical phase or 'movement'. Jackson's book was followed a few years later, in 1920, by another major study of the 1890s, this time by Osbert Burdett and called simply *The Beardsley Period*.

So from very early on, Beardsley was recognised by historians both as an outstanding genius in his own right and as the dominating artistic personality of his particular historical moment, a view which remains in essence unchanged to this day.

Beardsley's reputation is not merely posthumous: he made an enormous impact in his own short lifetime and the phrase 'the Beardsley period' was in fact originally coined by Beardsley's friend Max Beerbohm in 1895, less than three years after Beardsley first came to public notice.

Beardsley's contemporary fame and his continuing and indeed ever growing historical reputation raise two immediate problems which must be dealt with before any other aspect of his achievement can be examined. Beardsley was exclusively a graphic artist working mainly as an illustrator and decorator of books. In general, drawing has always been considered a minor medium for art compared with painting, and the arts of design or 'applied arts' inferior to the 'fine' arts of painting and sculpture. Furthermore, Beardsley's art reached its public primarily through photo-mechanical reproductions, and to some extent was even deliberately designed to suit the reproduction process. Beardsley himself was evidently acutely aware of the problems this created for the status of his art. In a letter of 25 December 1891 he wrote: 'How little the importance of outline is understood even by some of the best *painters*,' and in an essay on posters published at a time when he himself was designing them (Plate 17) he complained: 'The popular idea of a picture is something told in oil or writ in water [i.e. a watercolour] to be hung on a room's wall or in a picture gallery.' His further comments on contemporary critical attitudes to posters in this article can equally be applied to his own drawings as they appeared in books and periodicals: 'The critics can discover no brushwork to prate of, the painter looks askance upon a thing that achieves publicity without a frame, and beauty without modelling, and the public find it hard to take seriously a poor printed thing ...' (*The Art of the Hoarding, New Review*, July 1894).

However, although Beardsley complained, the truth is that he lived in an age when, in England particularly, the arts of design had undergone a great renaissance and critical attitudes were changing. An early milestone in this renaissance was the formation in 1861 by William Morris of his own design firm Morris, Marshall, Faulkner and Co., the prospectus of which stated: 'The growth of decorative art in this country ... has now reached a point at which it seems desirable that Artists of reputation should devote their time to it.' Thus was established the idea that an *Artist* with a capital A could practice the arts of design and thus was founded what became known as The Arts and Crafts Movement.

By the 1890s, the arts of design had become dominant in England to the point where a well-known critic and designer Gleeson White could write:

'Today is essentially a time when mean things are done so finely that future ages may refer to it as a period when the minor arts attracted the genius and energy now – from modesty or timidity – diverted from heroic enterprises. So as we collect the bric-à-brac of certain periods, and pay thousands for a piece of porcelain or some other article of the craftsman's production, it may be that other ages will pass by our pictures and poems with a smile of contempt, and collect our book covers, our short stories, and a hundred ephemeral products, with keen interest. In place of the epic, a quatrain or a sonnet; instead of fresco, a black and white sketch; no longer a cathedral, but a book cover; such, it seems, will be the verdict of the historian of the closing years of the nineteenth century.'

This passage occurs in *Artistic Book Covers*, a long

article published in *The Studio* magazine in 1893, and it provides an important key to an understanding of Beardsley's art from the aspect of the status of its medium. White's prophecy of the verdict of the historian has turned out to be substantially correct, for who can doubt that Beardsley's astonishing illustrations to Wilde's *Salome* or his illustrated edition of *Le Morte Darthur* with its marvellous cover, reproduced by White in his article (Plate 7), are among the most memorable works of art produced in England in the 1890s?

The fact that Beardsley's entire reputation, in his own day and ever since, rests on the basis of mechanical reproductions of his work is one of the most astonishing in the history of art. Even today, indeed, more than ever, in spite of the availability of high quality colour reproductions, people flock to the world's museums to see the works of the great painters in the original. We cannot satisfactorily find Van Gogh or Rembrandt between the covers of a book, but Beardsley we can: the essence of his art can be fully experienced here in this very volume, and it is through pages of reproductions like these that Beardsley has always cast his spell.

What is the explanation of this phenomenon? To begin with Beardsley was an artist whose natural means of expression was drawing. Furthermore, from the start his vision led him to a form of drawing in which line always predominated over tone. His appearance coincided with the development of photo-mechanical reproduction processes, and of one in particular, the line-block, which, once Beardsley had made some slight adjustments of his technique to suit it, enabled his work to be reproduced with a degree of fidelity which made the reproduction as near to the original as to make no practical difference to its appreciation. To this fidelity was allied cheapness and the possibility of mass production without loss of quality and it was through the combination of these factors that Beardsley found an audience unprecedentedly wide for a great artist. He thus occupies an important, indeed unique, place in the history of that democratisation of art which had been gathering pace through the nineteenth century with the growth of public art museums and exhibitions, and was vastly accelerated by the advent of photo-mechanical methods of reproduction.

Beardsley's art undoubtedly created a tremendous shock; his success in his own time was always a *succès de scandale* and his fame closer to notoriety. This shock stemmed from the nature of his subject matter but was compounded by the originality of his style. Contemporary public response is encapsulated in *The Times*'s description of the *Salome* drawings (Plates 11–16, Figs. 19–21) as: 'fantastic, grotesque, unintelligible for the most part and so far as they are intelligible repulsive' and *The Westminster Gazette*'s now famous comments on Beardsley's contributions to number one of *The Yellow Book*: 'We do not know that anything would meet the case except a short Act of Parliament to make this kind of thing illegal.' Beardsley was labelled a Decadent.

There is much confusion about the meaning of this term as applied to the art and literature of the late nineteenth century. Decadence was essentially an extreme form of Romanticism which in turn was the expression of the response by artists to changes in society brought about by the industrial revolution. As European society became increasingly dominated by the purely materialistic demands of wealth creation, so artistic and spiritual life came under increasing pressure. The new ruling class of the industrial and commercial bourgeoisie evolved powerful social conventions and even passed laws to control social behaviour and to prevent or repress the public acknowledgement or discussion of inconvenient realities. As Osbert Burdett put it in *The Beardsley Period*: 'Victorian convention imposed, in the name of decency, a conspiracy of silence concerning them ... The facts about industrial life, social life, private life, were suppressed and the fate of anyone who mentioned [them] was to be denounced as a corrupter of morals. The only remedy was ruthlessly to strip the masks from the realities.'

Decadent artists then were Realists, artists whose primary concern was to depict those aspects of human nature, human behaviour or of society that convention repressed or ignored. Realism in this sense was in fact a major movement in art and literature from the mid-nineteenth century, its founders the painter Gustave Courbet and the writer Emile Zola. But the Decadents took only their point of departure from

Fig. 1
FREDERICK H. EVANS
Photograph of Beardsley

PLATINUM PRINT, 13 × 10 CM. 1895. LONDON, THE NATIONAL PORTRAIT GALLERY

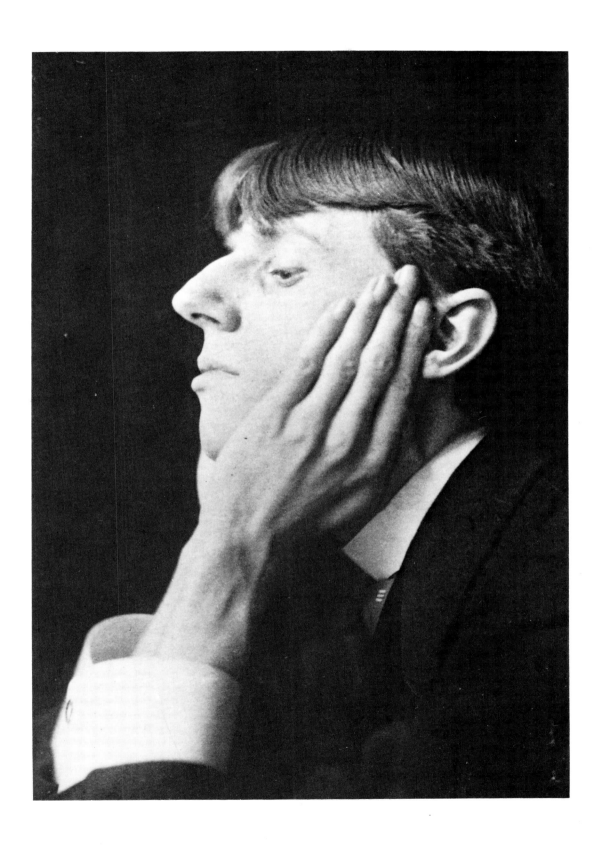

Realism, and whereas the true Realists wanted their art to possess all the grit and rawness of life itself, the essence of the Decadent approach was to make their subject matter as exquisitely beautiful as possible, an aesthetic doctrine which could be traced back to Baudelaire and Théophile Gautier, both important writers for Beardsley (Plate 44, Fig. 20). To this end the Decadents tended to avoid dealing with working-class or peasant life, leaving this to their pure Realist cousins, and chose to do battle in that other great area of Victorian repression, sexuality, which gave more scope for lyrical treatment and above all offered an alternative world, one of warmth, pleasure and fantasy, to the ugly, harsh realities of the Victorian age. Similarly they also turned to all the arts, both as a context for life and as a source for their own art. However, although there is this undeniable element of escapism among the Decadents, they did not, unlike their contemporaries the Impressionists, create an art that was purely hedonistic and sensuous. Their work is always bitter-sweet, always aware of reality, and pervaded by a sense of tragedy, an awareness of mortality and of *vanitas*.

Sexuality is one of the principal facts of human existence and one of the principal themes of art. A crucial element in our perception of Beardsley's greatness is that he took and explored this subject at the time and in the fashion that he did. But the range of Beardsley's art goes beyond this to embrace many more of those interconnecting areas of human thought, feeling and experience that have always made up the thematic content of great art. Beardsley, furthermore, worked within the established old master conventions in respect of subject matter, which demanded that the greatest art, what was known as 'high art' or 'history painting', should be based on subjects found in history, mythology, religion and literature, particularly that of ancient Greece and Rome. However, by Beardsley's time these conventions, which had dominated European art since the Renaissance, had been challenged by the rise of Realism which substituted the direct perception of man and the world for the use of history and myth. Yet another aspect of Beardsley's greatness is that he created a highly successful and original synthesis of the Realist/Decadent vision of the world and the traditions of 'high art'.

Beardsley's style is similarly an extraordinary synthesis of the old and the new. His stylistic development is extremely interesting. His earliest works, the brilliant juvenilia of his schooldays, are mostly carica-tures, works based on a direct and penetrating observation of his fellow human beings which always remained a fundamental ingredient of his art. He then discovered the strongly linear, decorative and mythologising art of Edward Burne-Jones, who gave him early advice and encouragement. Beardsley worked backwards to the roots of Burne-Jones's style in the early Renaissance masters, where he was particularly affected by Mantegna. At this point Beardsley came across the work of Whistler, the great pioneer of modern art in England, and from him appears to have absorbed in a very short time the entire history of modern art up to date. He was especially influenced by the increasing stylisation and abstraction that had become by that time one of its distinguishing features. It is worth considering some of the reasons for this modernist rejection of the naturalistic representation of the world which had been the basis of European art from the Renaissance to the mid-nineteenth century. The development of photography was one. The desire of artists to make art that was real and truthful in itself, not an illusion or imitation of reality, was another. Yet another, particularly important for Beardsley, was the desire to make art with a more intensely decorative character than was possible within the conventions of Renaissance illusionism. Yet another was the desire to remove art from the material world, to emphasise its character as something purely of the mind and imagination of the artist – the very important doctrine of 'art for art's sake'. There was also the equally important theory that pictorial art could and should be brought closer to the form of music, that just as music expresses mood and feeling through particular sounds and combinations of sounds, expression in art can come from particular forms, lines or colours, and combinations of these that are in essence invented by the artist rather than being direct imitations of reality. The pervasiveness of this idea is reflected in the virtual obsession with music of Beardsley and many other early modern artists. Finally, early modern European art was strongly influenced by the highly stylised, decorative and non-naturalistic character of the Japanese woodblock prints (also realist in subject) which began to flood into Europe after the reopening of Japanese trade with the West in the early 1850s. These offered European artists a completely fresh set of pictorial conventions with which to deal with the image of the real world.

Beardsley absorbed all this without losing one iota of his penetrating vision of reality. The result was the

extraordinary phenomenon of his mature style, in the best examples of which there is an absolutely perfect and uncanny balance between a powerful, purely abstract, decorative or 'musical' structure of the drawing and an equally powerful representation of reality. But the formal structures of Beardsley's drawings, exquisitely beautiful as they are, are more than purely decorative. Perhaps the most important thing of all to understand about Beardsley's way of drawing is that it is always intensely *expressive*: the vision, the feeling or idea he wants to convey is embodied as much in the quality of his lines, in the shapes that he gives to things and in the overall compositional structures of his drawings, as in the thing depicted. This ability to recreate reality in the image of the artist's own vision is fundamental to all great art and Beardsley possessed it to as high a degree as any artist ever has. The vision that Beardsley was thus able so effectively to express is, furthermore, of a peculiar power and intensity. The reason for this is that for all his roots in tradition, Beardsley represents a new breed of artist, the kind who may work with accepted ideas, subjects and conventions but when he does so treats them in terms of his own deepest instincts, working, that is to say, out of his unconscious

mind. This is why when he draws conventional subjects, they turn out to be so startlingly unlike any previous treatments of such subjects. The outstanding example of this is perhaps the *Salome* drawings, which after all are basically Bible illustrations, although it is sometimes difficult to remember this when looking at them.

The whole notion of art as something that should come direct from the artist's unconscious mind, from his personal experience of universal human feelings, is central to modern art, and this, added to the modernism of Beardsley's style, places him firmly among its founding fathers.

Baudelaire had a theory that the best account of a work of art could be another work of art, a poem or a piece of prose. Certainly the essence of Beardsley's art has never been better evoked nor its impact better described than by D.H. Lawrence when he introduced an album of Beardsley drawings into his first novel *The White Peacock* published in 1911:

It happened, the next day after the funeral, I came upon reproductions of Aubrey Beardsley's "Atalanta" [Fig. 34], and of the tail piece to "Salome" [Fig. 2] and others. I sat and looked and my soul leaped out

Fig. 2
The Powder Puff (Tailpiece to *Salome*)

INK DRAWING, 16.5 × 17.5 CM. 1893. CAMBRIDGE (MASS.), FOGG ART MUSEUM

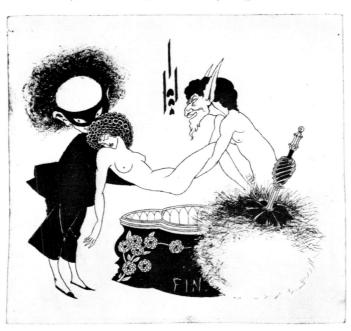

upon the new thing. I was bewildered, wondering, grudging, fascinated, I looked a long time, but my mind, or my soul, would come to no state of coherence. I was fascinated and overcome, but yet full of stubbornness and resistance ... I went straight to Emily, who was leaning back in her chair, and put the "Salome" before her.

'Look' said I, 'look here!'

She looked; she was short-sighted, and peered close. I was impatient for her to speak. She turned slowly at last and looked at me, shrinking, with questioning.

'Well?' I said.

'Isn't it — fearful?' she replied softly.

'No — why is it?'

'It makes you feel — Why have you brought it?'

'I wanted you to see it.'

Already I felt relieved, seeing that she too was caught in the spell ...

'Give it to me, will you?' George asked, putting out his hand for the book. I gave it to him, and he sat down to look at the drawings ...

'I want her more than anything — And the more I look at these naked lines, the more I want her. It's a sort of fine sharp feeling, like these curved lines. I don't know what I'm saying — but do you think she'd have me? Has she seen these pictures?'

'No.'

'If she did perhaps she'd want me — I mean she'd feel it clear and sharp coming through her.'

'I'll show her and see.'

Aubrey Vincent Beardsley was born in Brighton on 21 August 1872. His mother Ellen Agnus came from a comfortable middle-class family, called Pitt. His father Vincent Beardsley had married Ellen Pitt in 1870 on the strength of an inheritance which rapidly disappeared or was perhaps inadequate for marriage in the first place, and the family was dogged by poverty from the time of Aubrey's birth. Aubrey himself remained acutely conscious of the importance of money all his life, as his letters reveal, and struggled continuously against the lack of it. He and his elder sister Mabel (born in 1871) were brought up largely by their mother who also became the principal supporter of the household, working as a governess and music teacher. She insisted on educating her children musically, playing to them a programme of six carefully chosen pieces every night, and she guided their reading in much the same way. In her reminiscences recorded by the Beardsley scholar R.A. Walker she

said: 'I would not let them hear rubbish and ... I would not let them read rubbish.' The result was that by the time he went to boarding school in the autumn of 1879 at the age of seven Aubrey Beardsley was exceptionally literate for his age and, apparently, something of a musical prodigy. The school was Hamilton Lodge at Hurstpierpoint on the South Downs near Brighton. One of the reasons, it seems, for this choice was its supposedly healthful situation, for Beardsley had already begun to show signs of the tuberculosis that killed him 19 years later. His mother stressed that Aubrey was always a fragile child 'like a delicate little piece of Dresden china' and she recounted that he once 'helped himself ... by a fern up a high flight of steps.' At Hamilton Lodge Beardsley began to compose poetry and to draw regularly in addition to pursuing his musical studies.

In the autumn of 1881 Ellen Beardsley decided to move to Epsom for the sake of Aubrey's health and the family remained there for two years. Little is known of this period except that towards the end of it Beardsley received his first commission and first payment for drawings. This was from Lady Henrietta Pelham who befriended the Beardsley family at this time. A group of 15 of these drawings was preserved by Lady Henrietta together with a letter to her from the artist dated 1 February, probably of 1883 when Beardsley would have been 10: 'Dear Madam. The drawings which I sent you were all copies from different books. The little figures on the bench and *Secrets* were out of the book you sent me, the former I thought so very sweet that I was in a great hurry to draw it. I often do little drawings from my own imagination but in doing figures the limbs are apt to be stiff and out of proportion and I can only get them right by copying.' The drawings were in fact copies made from books written and illustrated by Kate Greenaway (1846–1901), a fact whose significance for Beardsley's later development has been largely overlooked.

Kate Greenaway's books have an important place in the revival of book design and illustration that was in turn a major element in the general renaissance of design in England, the Arts and Crafts Movement, which as we have already seen provided a crucial context for Beardsley in the 1890s. The books were printed in colour from woodblocks in a technique evolved by the highly influential designer and illustrator Walter Crane in 1865. In style the illustrations already have the tendency to flatness, the degree of simplification and decorative character that, greatly

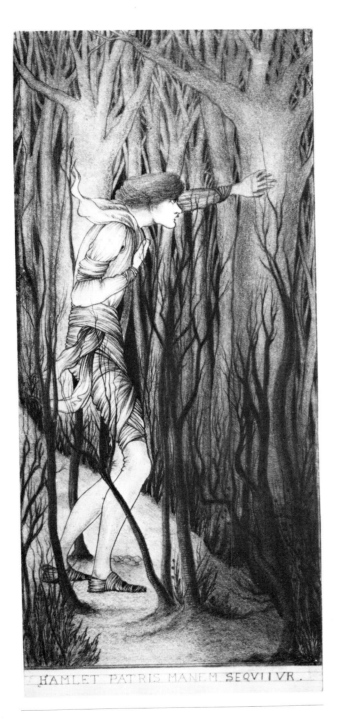

Fig. 3
Hamlet Patris Manem Sequiiur [sic]

PENCIL DRAWING, 29 × 13.5 CM. 1891. LONDON, THE BRITISH MUSEUM

In this context *Hamlet* can be seen as a self-portrait expressing Beardsley's anxiety for the future, born of his awareness of the fatal disease that possessed him. The last line of verse in particular seems a clear indication of Beardsley's sense that although barely on the threshold of a career he might yet be denied time for achievement.

Other drawings of late 1891 and early 1892 show the influence of Mantegna and of Walter Crane besides that of Burne-Jones, but some time in the spring of 1892, after another period of illness which prevented him from drawing, Beardsley began a series of remarkable works in which the effects of Whistler's modernism and of Japanese art suddenly make themselves felt in a style which as Beardsley himself later said was 'an entirely new method of drawing and composition, suggestive of Japan, but not really japanesque. Words fail to describe the quality of the workmanship.' He added, in another letter: 'In certain points of technique I achieved something like perfection at once and produced about twenty drawings in the new style in about a couple of months.' And not only had Beardsley found a personal style: in these drawings his own unique vision of the world springs fully into being already possessed of the compulsive quality which gives his most characteristic work all the fascination of the snake for the rabbit: 'The subjects,' wrote Beardsley, 'were quite mad and a little indecent. Strange hermaphrodite creatures wandering about in Pierrot costumes or modern dress; quite a new world of my own creation.'

When he wrote these last words Beardsley was probably thinking of *The Birthday of Madame Cigale* (Fig. 4) with its procession of astonishingly bizarre visitors bearing gifts for the half-naked Madame Cigale, to all appearances a courtesan. This drawing already displays the technical perfection of which Beardsley quite rightly boasted and with it emerges one of the most fundamental and significant aspects of Beardsley's art: his ability to express even the most bizarre fantasies in forms of great purity and beauty. He went to the heart of the matter when he described his new drawings as 'Fantastic impressions treated in the finest possible outline' and 'extremely fantastic in conception but perfectly severe in execution'.

In what are probably slightly later drawings in the series *Les Revenants de Musique* (Plate 1) and *Le Dèbris* [sic] *d'un Poète* (Fig. 5) he matches severity in execution with severity in composition, eliminating the sort of decorative detail that proliferates in *Madame Cigale*. The second of these in particular is a

13

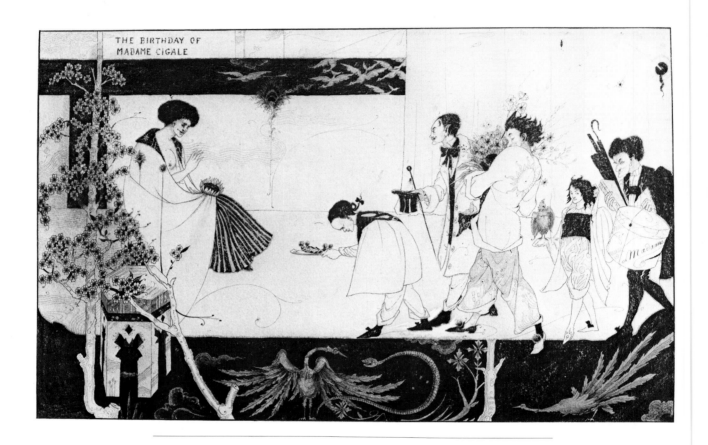

Fig. 4
The Birthday of Madame Cigale

INK DRAWING, 25 × 39 CM. 1892. CAMBRIDGE (MASS.), FOGG ART MUSEUM

masterpiece in which Beardsley displays for the first time his ability to compose in a 'musical' way with 'notes' of pure black placed in finely judged relationships to each other and then balanced against large areas of pure white, and to define forms by barely more than a single bounding outline. The austere beauty of effect thus achieved in no way diminishes the expressive power of the image which suggests an alchemist or a rather odd monk at work as much as the clerk it actually is. The title, which translates as *The Remains of a Poet*, is, as Beardsley's titles so often are, on the face of it puzzlingly enigmatic. In fact this drawing, like *Hamlet*, can be seen as a symbolic self-portrait showing Beardsley at his desk at the job (to which he had returned after his illness of the winter of 1889–90) that by now he was finding increasingly

oppressive. The use of the word poet in the title can be explained by the fact that all his life Beardsley continued to see himself as a poet and man of letters as much as a draughtsman: he is presenting himself as mere debris, his creative energies debilitated by disease and a tedious daily routine. In this drawing Beardsley established the basic style of balanced masses of pure black and white that he was to use for much of his best work throughout his career. However he continued for some time to use the fantastic manner of *Madame Cigale* with its proliferation of tendril-like fine lines and decorative flourishes, and very dense, elaborate compositions remained an essential element of his art particularly for the expression of highly imaginative or fantastic themes.

In June 1892 Beardsley used his annual holiday

14

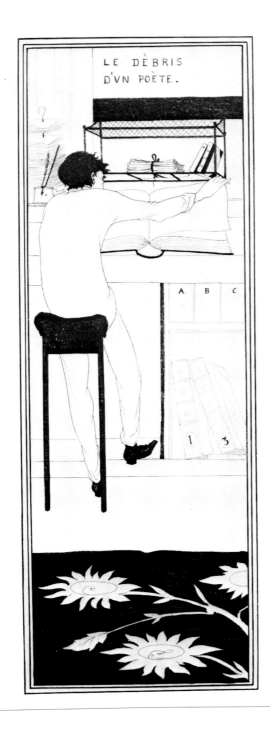

Fig. 5
Le Dèbris [sic] d'un Poète

INK AND WASH DRAWING, 35 × 12.5 CM. 1892. LONDON, THE
VICTORIA AND ALBERT MUSEUM

from the Insurance office to go to Paris for the first time. With him he took a portfolio of his new drawings. His obvious purpose was to visit the city that was the undisputed centre of modern art and to attempt to get reactions to his work from artists and critics. He may also have hoped for a few sales. Almost everything of what little is known of this trip comes from three letters, all written some months later. In the first he writes: 'I ... received the very greatest encouragement from the President of the Salon des Beaux Arts who introduced me to one of his brother painters as "un jeune artiste anglais qui fait des choses étonnantes!" ' (a young English artist who does amazing things). In the second letter he adds: 'The new work was regarded with no little surprise and enthusiasm by the French artists' and of the President of the Salon des Beaux Arts: 'the President, as you know, is the immortal Puvis de Chavannes. I never saw anyone so encouraging as he was.' Puvis de Chavannes (1824 – 1898), while occupying the most powerful official position in French art (equivalent to the President of the Royal Academy in England), was well respected by the avant-garde. His opinion therefore carried a particular weight with Beardsley who was much encouraged: 'I was not a little pleased, I can tell you, with my success,' he wrote in the third of his letters which mention his Paris trip.

This *succès d'estime* in Paris was followed almost at once by success of a more concrete kind in London. Beardsley's friend, the bookseller and photographer Frederick Evans, who took the most memorable of all portraits of Beardsley (Fig. 1), introduced him to the publisher J.M. Dent. Dent was looking for someone to illustrate the medieval English version of the legend of King Arthur, *Le Morte Darthur*, written by Sir Thomas Malory and first published by Caxton in 1485. Dent planned his edition of *Le Morte Darthur* to be in the medieval style, inspired by Caxton, of the illustrated and decorated books produced by William Morris at the Kelmscott Press, the private press he founded in 1889. Kelmscott books were hand-printed in very limited editions, illustrated by Burne-Jones with decorations by Morris, the illustrations and decorations printed from hand-cut wood blocks (Fig. 7). Dent hoped to produce the same effect more cheaply and to reach a wider market by using a young artist and the new photographic methods of reproduction. He met Beardsley at Evans's bookshop in Queen Street off Cheapside, a few minutes walk from the Insurance office in Lombard Street, presumably some time in July 1892. Dent looked at some draw-

15

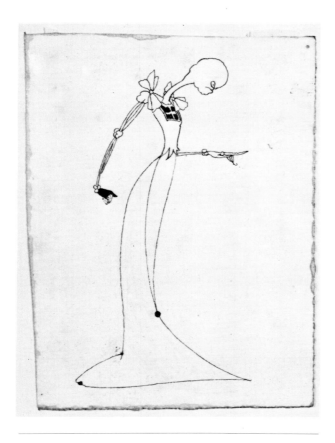

Fig. 6
Vignette for p. 44 in *Bon-Mots* of Samuel Foote
and Theodore Hook

INK DRAWING, 9 × 4.5 CM. 1893. LONDON, THE VICTORIA AND
ALBERT MUSEUM

ings and then asked Beardsley to make a sample illustration to *Le Morte Darthur*. Beardsley quickly produced *The Achieving of the Sangreal*, a drawing in his 'fine line' manner adapted to the medieval subject. Seeing it Dent immediately concluded a verbal agreement for Beardsley to illustrate the whole of *Le Morte Darthur* in two volumes to be issued to subscribers in monthly parts. The sample drawing eventually became the frontispiece to volume two. It was an enormous commission: in the autumn of 1892 Beardsley wrote to his old headmaster at Brighton describing it. 'There will be twenty full-page drawings ... about a hundred small drawings in the text, nearly 350 initial letters and the cover to design. The drawings I have already done have met with great

approval from all who have seen them. The first part will be coming out early next year.' He reported Dent's fee as £200 which later seems to have been raised to £250, 'not bad for a beginning' as he said. In the same letter he described a second commission Dent had given him to work on concurrently with *Le Morte Darthur*. This was for small drawings, called by him or Dent *Grotesques,* to decorate three small volumes of *Bon-Mots*, collections of the sayings of noted wits of the past such as Richard Sheridan. 'Just now I am finishing a set of sixty grotesques for three volumes of *Bon-Mots* soon to appear. They are very tiny little things, some not more than an inch high, and the pen strokes to be counted on the fingers. I have been ten days over them and have just got a cheque for £15 for the work — my first art earnings.' (Fig. 6). (He seems to have forgotten or discounted the money he had been paid for the Kate Greenaway drawings.)

He had evidently not yet been paid anything for *Le Morte Darthur*, but that commission combined with other small jobs like the *Bon-Mots* which were now coming in enabled him finally to leave the insurance office. In a letter of 9 December 1892 he wrote: 'I left the fire office about two months ago to the great satisfaction of said office and myself. If ever there was a case of the square boy in the round hole, it was mine.'

The 'fine line' style was particularly suited to the *Bon-Mots* and Beardsley also used it for the drawing, much more extraordinary than *The Achieving of the Sangreal*, which became the frontispiece to volume one of *Le Morte Darthur, How King Arthur saw the Questing Beast* (Plate 3). Beardsley signed and dated this 8 March 1893, making it one of his rare precisely datable drawings. For the rest of *Le Morte Darthur* Beardsley developed his pure black and white manner, giving it an intensely medieval flavour to produce a richly decorative and expressive effect (Plates 3–8). A comparison of a page (Fig. 8) and an illustration (Fig. 9) from *Le Morte Darthur* with a page from one of the Kelmscott books that Beardsley was supposed to be imitating (Fig. 7) reveals at once the distance he had travelled from the restrained and

Fig. 7
A Page from the Kelmscott Chaucer

LETTERPRESS AND WOODBLOCK PRINT, 1896.
LONDON, VICTORIA AND ALBERT MUSEUM

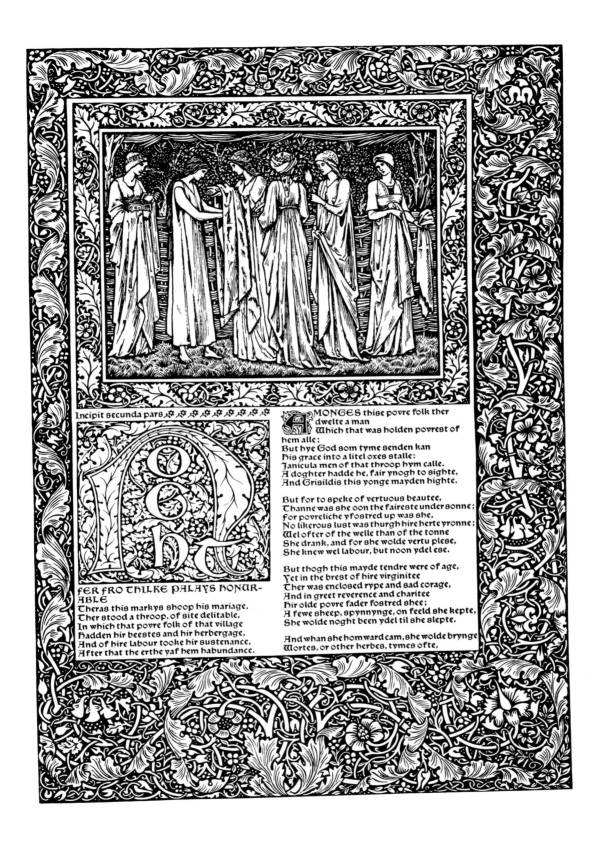

Incipit secunda pars ❀ ❀ ❀ ❀ ❀ ❀

OGHT FER FRO THILKE PALAYS HONUR-
ABLE
Theras this markys shoop his mariage,
Ther stood a throop, of site delitable,
In which that povre folk of that village
Hadden hir beestes and hir herbergage,
And of hire labour tooke hir sustenance,
After that the erthe yaf hem habundance.

AMONGES thise povre folk ther
dwelte a man
Which that was holden povrest of
hem alle;
But hye God som tyme senden kan
His grace into a litel oxes stalle.
Janicula men of that throop hym calle.
A doghter hadde he, fair ynogh to sighte,
And Grisildis this yonge mayden highte.

But for to speke of vertuous beautee,
Thanne was she oon the faireste under sonne;
For povreliche yfostred up was she,
No likerous lust was thurgh hire herte yronne;
Wel ofter of the welle than of the tonne
She drank, and for she wolde vertu plese,
She knew wel labour, but noon ydel ese.

But thogh this mayde tendre were of age,
Yet in the brest of hire virginitee
Ther was enclosed rype and sad corage,
And in greet reverence and charitee
Hir olde povre fader fostred shee;
A fewe sheep, spynnynge, on feeld she kepte,
She wolde noght been ydel til she slepte.

And whan she homward cam, she wolde brynge
Wortes, or other herbes, tymes ofte,

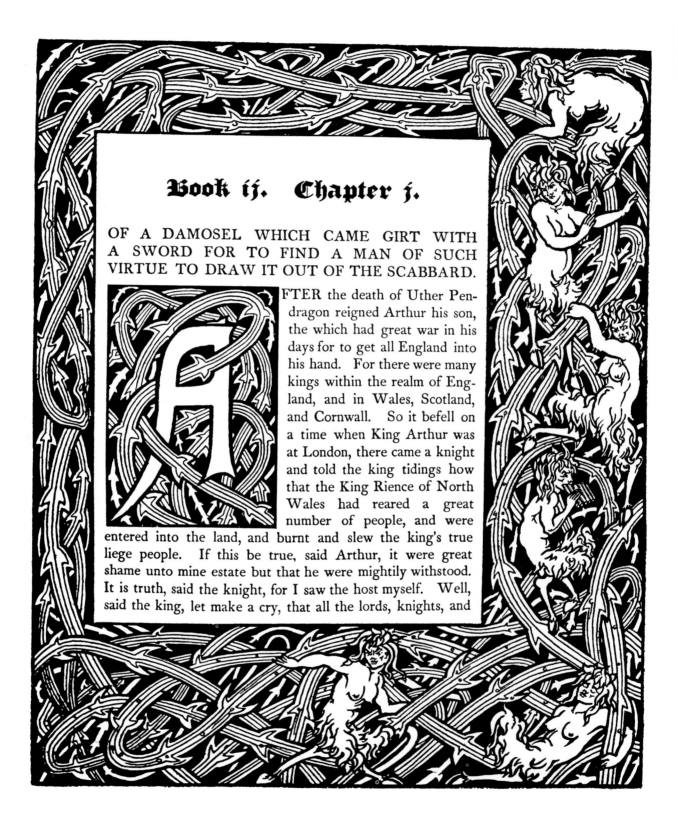

Book ij. Chapter j.

OF A DAMOSEL WHICH CAME GIRT WITH A SWORD FOR TO FIND A MAN OF SUCH VIRTUE TO DRAW IT OUT OF THE SCABBARD.

AFTER the death of Uther Pendragon reigned Arthur his son, the which had great war in his days for to get all England into his hand. For there were many kings within the realm of England, and in Wales, Scotland, and Cornwall. So it befell on a time when King Arthur was at London, there came a knight and told the king tidings how that the King Rience of North Wales had reared a great number of people, and were entered into the land, and burnt and slew the king's true liege people. If this be true, said Arthur, it were great shame unto mine estate but that he were mightily withstood. It is truth, said the knight, for I saw the host myself. Well, said the king, let make a cry, that all the lords, knights, and

careful medievalism of Morris. The light, delicate foliage of Morris's borders has been replaced by powerful organic plant forms pulsing with life; the figures of Burne-Jones, mere decorative ciphers, have been replaced by startlingly vivid personages evidently in the grip of strange emotions.

A mutual friend of Beardsley and Morris, the designer Aymer Vallance, made the mistake of showing Morris a printed proof of one of *Le Morte Darthur* drawings in an attempt to interest the great man in this rising talent. Morris loathed it on account of the mechanical reproduction method, said 'a man ought to do his own work', and was irritated by the imitation of the Kelmscott style. Also, although there is no extant evidence for this, he must above all have been deeply disturbed by the transformation of this style wrought by Beardsley's modernism. As Figures 8 and 9 reveal, his ideal medieval dream world had in Beardsley's hands emphatically lost its innocence. Beardsley reported Morris's reaction in a letter: 'William Morris has sworn a terrible oath against me for daring to bring out a book in his manner.' And he added, significantly, 'The truth is that, while his work is a mere imitation of the old stuff, mine is fresh and original...'

Meanwhile, some time earlier, probably in November 1892, another great opportunity had presented itself to Beardsley. He was introduced to Lewis Hind, then sub-editor of the *Art Journal* but planning to launch his own art magazine to be called *The Studio*. He was looking for something startling for the first issue and in Beardsley's work he found it. He commissioned the distinguished critic, etcher, and friend and biographer of Whistler, Joseph Pennell, to write an article on Beardsley and he commissioned Beardsley himself to design the cover of the new magazine.

The first issue of *The Studio* duly appeared in April with Pennell's article *A New Illustrator: Aubrey Beardsley*, accompanied by eight examples of Beardsley's work including *Madame Cigale* (Fig. 4), *Les Revenants de Musique* (Plate 1), *Siegfried* (Plate 2), *J'ai Baisé ta Bouche, Iokanaan* (Fig. 10) and two pages

from *Le Morte Darthur*, a complete conspectus of Beardsley's achievement to date.

Pennell's article was as acute as his choice of drawings, starting with a prophetic pre-emptive strike against the critics: 'Criticism of art today is merely the individual expression of persons who mostly know nothing about their subject,' and then going straight to the heart of Beardsley: 'an artist whose work is quite as remarkable in its execution as in its invention: a very rare combination.' He also at once perceived Beardsley's creation of an original art from a synthesis of many traditional elements: ' ... though Mr Beardsley had drawn his motives from every age and founded his styles — for it is quite impossible to say what his style may be — on all schools, he has not been carried back into the fifteenth century or succumbed to the limitations of Japan; he has recognised that he is living in the last decade of the nineteenth century.' The appearance of *The Studio* further stimulated the interest in Beardsley that, as Beardsley

Fig. 8
A Page from *Le Morte Darthur*

LETTERPRESS AND LINE BLOCK PRINT, 1893.

Fig. 9
Chapter Heading for *Le Morte Darthur*

INK DRAWING, 11.8 × 10.2 CM. 1893. WASHINGTON, LIBRARY OF CONGRESS, ROSENWALD COLLECTION

19

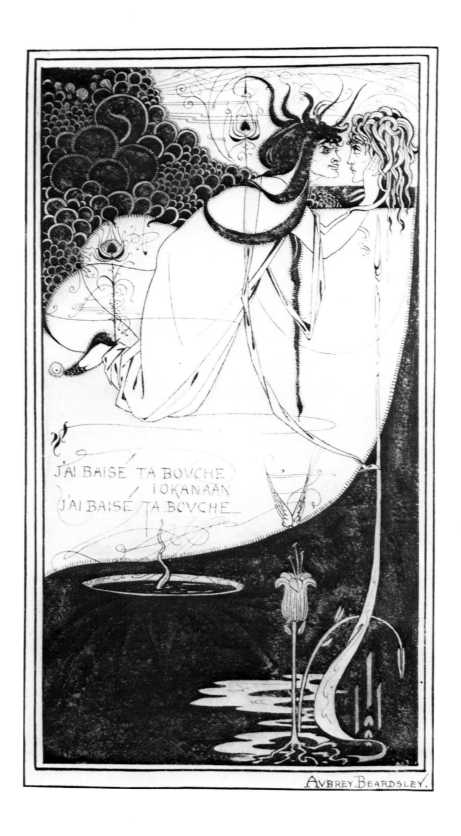

recorded, slightly tongue-in-cheek, in a letter of February 1893, had been steadily growing since his meeting with Dent: 'Behold me, then, the coming man, the rage of artistic London, the admired of all schools, the besought of publishers, the subject of articles! ... I have fortune at my foot ... I have really more work on my hands than I can possibly get through and have to refuse all sorts of nice things.'

One 'nice thing' Beardsley did not refuse was his next major commission, from the publisher John Lane, to illustrate Oscar Wilde's play *Salome*. This arose directly out of the publication in *The Studio* of *J'ai Baisé ta Bouche, Iokanaan* which was in fact an illustration to *Salome* done quite spontaneously by Beardsley after reading the play which Wilde had written in French and had published simultaneously in Paris and London on 22 February 1893. Some time in March, Wilde sent a copy of this edition to Beardsley inscribed: 'March '93. For Aubrey: for the only artist who, beside myself, knows what the dance of the seven veils is, and can see that invisible dance. Oscar.'

This inscription clearly suggests that Wilde sensed a strong affinity between Beardsley's art and his own play (in which Salome dances the dance of the seven veils), a suggestion reinforced by the fact that Wilde took the trouble at all to send such an elaborately dedicated copy to someone, on all the evidence, he had known only slightly up to this time. Wilde was absolutely right: Beardsley fell upon *Salome*, immediately putting down its central image, the climactic moment when the triumphant Salome embraces the severed head of John the Baptist, in the drawing which was published in *The Studio*. Then, after receiving Lane's commission, he went on, between late May and the end of November 1893, to make a group of illustrations which collectively constitute his highest achievement and among which are to be found the most richly inventive, formally daring, powerfully expressive and stylistically original of all his works. Among them is a completely redrawn and infinitely superior version of *J'ai Baisé ta Bouche,*

Fig. 10
J'ai Baisé ta Bouche, Iokanaan

INK DRAWING WITH ADDED GREEN WATERCOLOUR, 28 × 15 CM. 1893.
PRINCETON UNIVERSITY LIBRARY,
GALLATIN, BEARDSLEY COLLECTION

Iokanaan, which, done in August, about four months after the first version, clearly indicates the dramatic increase in Beardsley's powers stimulated by the work on *Salome.*

Beardsley was working concurrently on *Le Morte Darthur* where his new sophistication can also be traced.

The style that Beardsley established through the summer and autumn of 1893 belongs in a wider context to the history of Art Nouveau. Developing out of the English Arts and Crafts Movement, Art Nouveau emerged in the early 1890s as an international phenomenon which swept the western world in all the applied arts and had its fine art equivalent in what is known as Symbolism. Beardsley's illustrations to *Le Morte Darthur* and particularly its cover design, together with the drawings for *Salome*, not only constitute an important milestone in the emergence of Art Nouveau but are among those works by which the style is defined.

After completing *Salome* Beardsley turned away from the fantastic Biblical world of Wilde and the equally remote medieval one of *Le Morte Darthur* which had both exercised such a powerful imaginative sway on him and returned to the development of his own peculiar personal vision of life, art and literature. He thus entered upon the next distinct phase of his brief career, the *Yellow Book* period (Plates 18–22,24,25).

The Yellow Book, 'a new literary and artistic Quarterly' in Beardsley's phrase, was the brain child of himself and his friend Henry Harland, an American writer who had settled in London in 1889 and quickly moved into the avant-garde artistic circle around his fellow American, Whistler. 'Our idea,' wrote Beardsley, in a letter of early January 1894, 'is that many brilliant story painters and picture writers cannot get their best stuff accepted in the conventional magazine, either because they are not topical or perhaps a little risqué.' They took their idea to John Lane who agreed to act as publisher. Harland was appointed Literary editor and Beardsley art editor. The first number was planned to appear on 15 April 1894.

In February 1894 the English edition of *Salome* was published with Beardsley's illustrations and, as we have seen, created a sensation. In March he designed a poster for the actress Florence Farr which also attracted considerable comment of the same kind (Plate 17). And when the first issue of *The Yellow Book* duly appeared in April it too caused the conven-

tional press to froth at the mouth with rage. Beardsley's success, hitherto confined to artistic circles in London, suddenly turned into public notoriety.

With his sister Mabel, Beardsley now bought a house at 114 Cambridge Street, Pimlico, the striking decoration of which was described by his friend, the artist William Rothenstein: 'The walls of his rooms were distempered a violent orange, the doors and skirtings were painted black.'

The monthly parts of *Le Morte Darthur* continued to appear through 1894, until publication was completed in November. The first volume of *Bon-Mots* published in 1893 was reprinted in 1894 and two further volumes appeared (Fig. 13). Beardsley was designing a series of modern novels, the *Keynotes*, for Lane (Plates 23 and 43) and undertaking other commissions for books and posters. *The Yellow Book* also continued to appear, volume four in January 1895.

The period from early 1894 to early 1895 was Beardsley's *annus mirabilis*, the months when he definitively stamped himself on his epoch, the moment, precisely, that Max Beerbohm had in mind when he coined the phrase 'the Beardsley period.' It all came to an abrupt end on April 5 1895 when Oscar Wilde was arrested on a criminal charge of committing indecent acts, an event which as Wilde's friend and biographer Frank Harris later wrote: 'was the signal for an orgy of Philistine rancour such as even London had never known before. The puritan middle class, which had always regarded Wilde with dislike as an artist and intellectual scoffer ... now gave free scope to their disgust and contempt ...' The morning following Wilde's arrest *The National Observer* declared in a leading article: ' ... and the Decadents, of their hideous conceptions of the meaning of Art ... there must be an absolute end.'

The Yellow Book was by this time an established public symbol of Decadence and when Wilde was reported to have taken with him to prison the book he was reading when arrested, a yellow paper covered French novel, several newspapers seized the opportunity and published the headline ARREST OF OSCAR WILDE YELLOW BOOK UNDER HIS ARM. As John Lane later said, 'It killed *The Yellow Book* and it nearly killed me.' It also in a sense killed Beardsley who was doubly vulnerable both as art editor of *The Yellow Book* and as the notorious illustrator of Wilde's *Salome*. Lane was in America when Wilde was arrested but he soon began to receive cables from his more respectable authors demanding

Beardsley's dismissal. Eventually he received one from the poet William Watson: 'Withdraw all Beardsley's designs or I withdraw all my books.' Lane became alarmed and cabled London directing that all Beardsley's work be removed from the fifth volume of *The Yellow Book*, then going through the press. This was done. Beardsley was, in effect, dismissed. *The Yellow Book* itself, as the writer E.F. Benson put it, 'turned grey in a single night, though it lingered on, feeble and quite respectable, for nine issues more.'

On 20 April Beardsley left the poisonous atmosphere of London and went to Paris. Probably not more than a week later, however, he made a very brief return visit to London, the purpose of which was to ask for advice and help from the writer and poet André Raffalovitch. Born in Paris in 1864 of wealthy Russian emigré parents, Raffalovitch had settled in London in 1882 and through lavish entertaining rapidly became well-known in literary circles. Although he had met Beardsley he had not apparently taken to him, so it must have been in some desperation that Beardsley turned to him for help. In the event Raffalovitch proved a saviour, possibly in more senses than one, since as well as providing the artist with generous financial support for the rest of his life he also brought about his conversion to the Catholic Church.

The Christian Raffalovitch was not Beardsley's only support in his last years; he had a curious counterpart in the splendidly pagan figure of Leonard Smithers who succeeded John Lane as Beardsley's publisher. Smithers was a remarkable man, a bibliophile solicitor from Yorkshire who dealt in and published erotica alongside avant-garde literature. He has been much maligned, with some reason, but deserves eternal credit both for his support of Beardsley right to the end, even when in severe financial difficulties himself, and for preserving intact Beardsley's extensive correspondence with him. His professional relationship with Beardsley began in the early summer of 1895 after Beardsley's return from Paris on May 5th. The poet Arthur Symons decided that a new magazine should be started to take over the territory abandoned by *The Yellow Book* when it sacked Beardsley. Smithers was to be its publisher, Symons the literary editor and Beardsley, naturally, the art editor. Symons's proposal was accepted by both other parties and it was agreed that the title, suggested by Beardsley, should be *The Savoy*. The first issue eventually appeared in January 1896.

Smithers not only took on Beardsley as art editor of *The Savoy*, he made an agreement to provide Beardsley with a regular income of £25 a week in return for his entire future output. This generous gesture restored some semblance of stability to Beardsley's life. But his circumstances had nevertheless been irrevocably changed by the consequences of the Wilde débâcle. London was not the same, Smithers was not the solid, respectable publisher that Lane always was and Raffalovitch, for all his religion, was, to say the least, an ambiguous figure.

In July Beardsley sold the black and orange house in Cambridge Street and moved briefly to a rented house in Chester Terrace. He then went abroad again, to Dieppe. He returned in August and left Chester Terrace for rooms, once used by Wilde for writing, at 10 St James's Place. In late August he went to Germany, visiting Cologne, where he wrote *The Ballad of a Barber* later published in *The Savoy* No 3, then to Munich and possibly Berlin. By late September he was in Dieppe again, finally returning to London in October to settle into his rooms in St James's. There he continued the work, started in Dieppe, on the first issue of *The Savoy*. In particular he made illustrations for his own story *Venus and Tannhäuser*, a version of the legend of Tannhäuser, the first four chapters of which were published in the first two issues of *The Savoy* with the title *Under the Hill*. Beardsley attached great importance to *Venus and Tannhäuser*: the first reference to it occurs in a letter of June 1894 and he was still working on it at the time of his death. It was clearly intended to be the major vehicle for the literary ambitions he never relinquished. Although unfinished it is a minor masterpiece, a quintessentially Decadent work that has ensured Beardsley the niche in literary history he so coveted. The manuscript was published in full by Smithers in 1907 and it has since been reprinted several times, notably by the Olympia Press, Paris, in 1959.

Beardsley's designs for *The Savoy* and his illustrations for *Under the Hill* mark a dramatic new development in his art, the result of an increasing orientation, since at least 1893, towards the art, literature, manners and mood of the eighteenth century, specifically eighteenth-century France. This led him, towards the end of 1895, to begin drawing in a manner derived from that of the contemporary line engravings made after the paintings of Watteau and the masters of the French Rococo. These eighteenth-century French engravings represent a pinnacle of the reproductive engraver's art: they were, and are, collected as works of art in their own right and Beardsley owned a number of them.

With this new style Beardsley's art took on a more settled, mature character. His compositions became more balanced and harmonious, in a word more classical, and his technical powers as a draughtsman reached new heights: the sureness and control with which he executed such intricate compositions as, for example, *The Abbé*, one of the illustrations for *Under The Hill* (Plate 28) is immensely impressive.

Some time in late 1895 the writer Edmund Gosse suggested to Beardsley that he should illustrate Alexander Pope's poem *The Rape of the Lock*. In his new eighteenth-century mood it is not surprising that Beardsley immediately began to do so. It is equally not surprising that he produced a masterpiece, his third great illustrated book after *Le Morte Darthur* and *Salome*. Pope's poem suited Beardsley perfectly at this time: a rococo satirical fantasy with an erotic theme, written, however, in the severely classical form of heroic couplets (Plates 29–32).

The 10 drawings for *The Rape of the Lock* were begun in London in early January 1896 and completed two months later in Paris where Beardsley had been living since the beginning of February. 'Paris suits me very well,' he wrote to Smithers. 'I believe I shall stay here a deuce of a time,' and, a week or so later: 'I don't know when I shall return to London — filthy hole where I get nothing but snubs and the cold shoulder.' However, about the middle of March, on impulse he decided to go to Brussels with Smithers. There his tuberculosis suddenly reasserted itself. He suffered a severe haemorrhage of the lung and was forced to remain in Brussels until early May when he was considered well enough to be brought back to London.

This attack was the beginning of the end, and Beardsley spent the last 22 months of his life constantly on the move in search of health and constantly battling to produce as much work as possible before the disease finally claimed him, which he was more than ever aware it might at any time: in July 1896 he made his will. For a time he held his ground and, motivated as he was, produced throughout 1896, at a feverish pace, work of astonishing quality.

Immediately after completion of *The Rape of the Lock* Smithers commissioned Beardsley to illustrate a translation he planned to publish of the ancient Greek comedy *Lysistrata* by Aristophanes. Beardsley completed this commission, for eight large drawings, be-

tween late June and early August 1896 while staying at a hotel in Epsom, 'The Spread Eagle'. The drawings (Plates 35–38), a complete contrast to *The Rape of the Lock* illustrations in every way, were done in a refined and purified version of the linear style of *Salome*. The book was published 'privately' by Smithers later in the year in a limited edition of 100 copies. It was Beardsley's fourth and, as it turned out, his last great illustrated book. It completes the quartet of master works, all the more astonishing for being so different from one another, which form the four cornerstones of the edifice of Beardsley's art.

As soon as he had finished *Lysistrata* Beardsley began illustrating the *Sixth Satire* of the Latin poet Juvenal in the same style (Plates 40–42) and towards the end of the year, returning to his rococo manner, he produced five drawings for the poet Ernest Dowson's play *Pierrot of the Minute,* two of them in particular of a haunting beauty. Throughout this period he also produced some 30 drawings for the successive issues of *The Savoy* until it ceased publication after the eighth number appeared in December 1896.

The Pierrot of the Minute was Beardsley's last completed commission; the book was published by Smithers in March 1897. By this time Beardsley's illness had advanced to the point where it prevented him working for long stretches at a time. On the advice of his doctors he continued to travel. In April he went to Paris for the autumn and in November moved with his mother to the Mediterranean resort of Menton on the French-Italian border. There he died in the night of the 15th-16th March 1898. He was 25 years old.

Although Beardsley produced relatively little during the last 15 months of his life, he was full of projects. He began an ambitious scheme of illustrations for Ben Jonson's play *Volpone* and a smaller scheme for Théophile Gautier's romantic novel *Mademoiselle de Maupin.* Both remained incomplete at his death but the frontispiece to *Volpone* (Plate 48), the drawing *The Lady with the Monkey* (Plate 44) for *Mademoiselle de Maupin* and a marvellous cover design he did for *The Houses of Sin* by Vincent O'Sullivan (Plate 45) show that his creative powers remained undiminished.

In conclusion, an anecdote. In May 1893, just after the appearance of *The Studio* article by Joseph Pennell, Beardsley and Pennell went to Paris together. Coming out of the Opera one evening they saw Beardsley's great artistic hero Whistler, whom Beardsley had never met, sitting at a café table. Pennell introduced them, but Whistler was cool and later made it clear to Pennell that he did not take Beardsley seriously. He remained cool when Pennell took Beardsley to his house the next day, and finally, the same evening, he failed to appear at a dinner party to which Beardsley had also been invited. Beardsley was hurt and angered and subsequently caricatured Whistler several times (Fig. 32). Something of a feud developed between the two, until one evening in May or June 1896 Beardsley went to the Pennell's house in London to show them *The Rape of the Lock* drawings, only to find Whistler there. He nevertheless produced the drawings and, the Pennells later recorded, 'Whistler looked at them at first indifferently, then with interest, then with delight. And then he said slowly: "Aubrey, I have made a very great mistake — you are a very great artist." And the boy burst out crying. All Whistler could say, when he could say anything, was "I mean it — I mean it — I mean it." '

24

Outline Biography

1872 21 August. Aubrey Vincent Beardsley born in Brighton.

1879 Sent to boarding school near Brighton. Begins to draw. First signs of tuberculosis appear.

1884 Sent to Brighton Grammar School where he is encouraged by his housemaster Arthur William King.

1889 Leaves school, moves to London.

1890 Becomes an insurance clerk in the City of London.

1891 Visits the artist Burne-Jones who gives crucial encouragement and recommends art classes.

1892 Develops personal style of drawing of *Madame Cigale* (Fig. 4), *Le Dèbris* [sic] *d'un Poète* (Fig. 5). Goes to Paris in June, taking drawings. Meets and is encouraged by Puvis de Chavannes. On return is commissioned to illustrate *Le Morte Darthur* (Figs. 8, 9, Plates 3-8).

1893 First issue of *The Studio* magazine, April, carries laudatory article on Beardsley by Joseph Pennell, and reproduces eight drawings. Soon after, Beardsley commissioned to illustrate Wilde's *Salome* (Figs. 19-21, Plates 11-16).

1894 Appointed art editor of *The Yellow Book* (Plates 18-22, 24, 25), a new magazine. Notoriety follows appearance of first issue of *The Yellow Book* just after Wilde's *Salome* published with Beardsley's illustrations.

1895 Arrest of Wilde. Beardsley dismissed from *The Yellow Book*. Makes agreement with publisher Leonard Smithers.

1896 Smithers, Beardsley and Arthur Symons bring out new magazine *The Savoy* (Fig. 31). Beardsley draws intensively throughout the year producing among much else the complete sets of illustrations to *The Rape of the Lock* (Plates 29-32) and *Lysistrata* (Plates 35-38).

1897 Advance of tuberculosis largely prevents Beardsley from working although he has many projects. Doctors advise travel. Moves to Mediterranean resort of Menton on French-Italian border.

1898 Dies in Menton during the night of 15-16 March, age 25 years 6 months.

Select Bibliography

John Russell Taylor, *The Art Nouveau Book in Britain,* London 1966, Edinburgh 1980.

Brian Reade, *Beardsley,* London 1967.

Stanley Weintraub, *Beardsley, a Biography,* London 1967. New enlarged edition *Beardsley, Imp of the Perverse,* Pennsylvania and London 1976.

Brigid Brophy, *Black and White, a Portrait of Aubrey Beardsley,* London 1968.

Henry Maas, T.L. Duncan and W.G. Good, (ed.), *The Letters of Aubrey Beardsley,* London 1971.

Malcolm Easton, *Aubrey and the Dying Lady, A Beardsley Riddle,* London 1972.

Brigid Brophy, *Beardsley and his World,* London 1976.

Miriam Benkovitz, *Aubrey Beardsley: an Account of his Life,* London 1981.

List of Illustrations

Plates

Text Figures

Comparative Figures

Plates

Les Revenants de Musique

INK DRAWING, 36 × 15 CM. 1892. PRIVATE COLLECTION

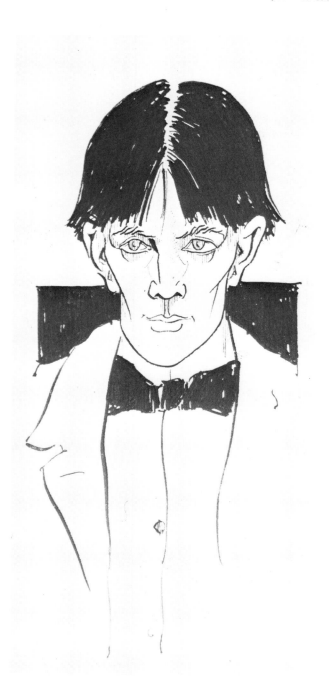

An early work in the 'fine line' style. Here Beardsley has already fully developed his extraordinary ability to create highly decorative compositions in which the whole sheet is first divided into a beautifully proportioned asymmetric geometric grid, within which small masses of black are then disposed, 'calling' to each other across the expanses of white. These in turn are animated by a few slender but dynamic lines. Beardsley was able to exploit this extremely economical manner of drawing to produce some of his greatest masterpieces.

Les Revenants de Musique, one of a group of drawings done around the spring and early summer of 1892, reveals Beardsley's obsession with music and especially with the operas of Wagner whose *Tristan and Isolde* and *Tannhäuser* were performed in London in 1892. There is no doubt that this passion for music played a part in the evolution of his style, together with the influence of the 'musical' art of Whistler.

No interpretation of this drawing has ever been offered. However the title translates as *The Ghosts of Music* and it clearly represents a romantic young man in a state of emotional exhaustion, haunted by the ghosts of some great music he has just experienced, probably, knowing Beardsley, a Wagner opera.

The *Self-Portrait* (Fig. 11) is among the earliest of the many, often highly imaginative, self-portraits that Beardsley made. Early though it is, it is among the most powerful and penetrating of them all and, taken with *Les Revenants de Musique*, underlines the sudden flowering of Beardsley's genius that took place in 1892.

Fig. 11
Self-Portrait

INK DRAWING, 25 × 9 CM. 1892. LONDON, THE BRITISH MUSEUM

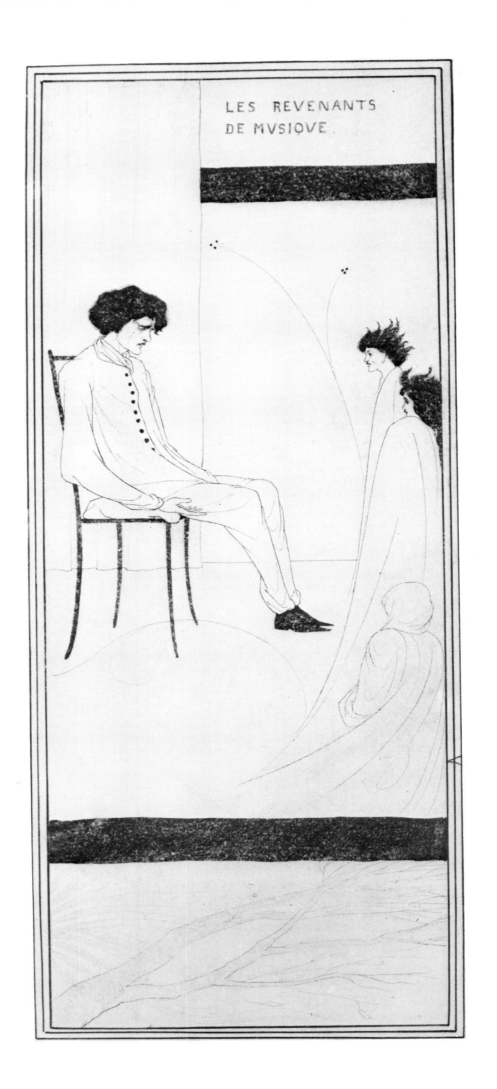

LES REVENANTS
DE MVSIQVE.

Siegfried, Act II

INK DRAWING, 40 × 28.5 CM. 1892. LONDON, THE VICTORIA AND ALBERT MUSEUM

Drawn probably towards the end of 1892. In a letter of February 1893 Beardsley described *Siegfried* as the culmination of his early 'fine line' style although about a month later he went on to produce *How King Arthur Saw the Questing Beast* (Plate 3). Beardsley presented this amazing drawing to Burne-Jones who, wrote Beardsley, 'has given my *Siegfried* a place of honour in his drawing-room.' Burne-Jones was quite right to do so since it is one of the greatest of all Beardsley's works, an utterly compelling fantasy in which Japanese, early Renaissance and Whistlerian influences are absorbed into a completely personal style and vision.

The drawing represents a moment in Wagner's 'dramatic poem' *Siegfried* which became the libretto for the opera. Siegfried has just killed the giant Fafner who, in the form of a scaly dragon, guarded the fatal treasure of the Nibelungs. Wagner's stage directions read: 'Fafner has rolled to the side in dying. Siegfried now draws the sword from his breast. In doing so his hand gets sprinkled with the blood; he draws it back quickly.

'Siegfried: "The hot blood burns like fire!"'

'Involuntarily he raises his fingers to his mouth to suck the blood from them.'

Professor Fred Brown (Fig. 12) was probably drawn not long after Beardsley started evening classes at Brown's Westminster School of Art in August 1891. It vividly reveals the immense impression that his visit to Whistler's Peacock Room in July had made on Beardsley: it is drawn in an imitation of Whistler's etching style, a peacock feather is included at top left and Whistler's famous butterfly signature appears at the lower left. Also Whistlerian is the exquisitely judged arrangement of the framed pictures hanging on the wall, their upper edges cut off so that they form an essentially geometric decorative pattern. This sort of composition became fundamental to Beardsley's art.

Fig. 12
Professor Fred Brown

INK DRAWING, 25.5 × 25.5 CM. 1891. LONDON, THE TATE GALLERY

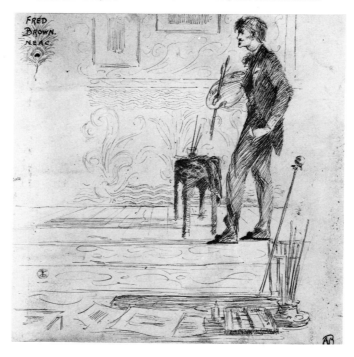

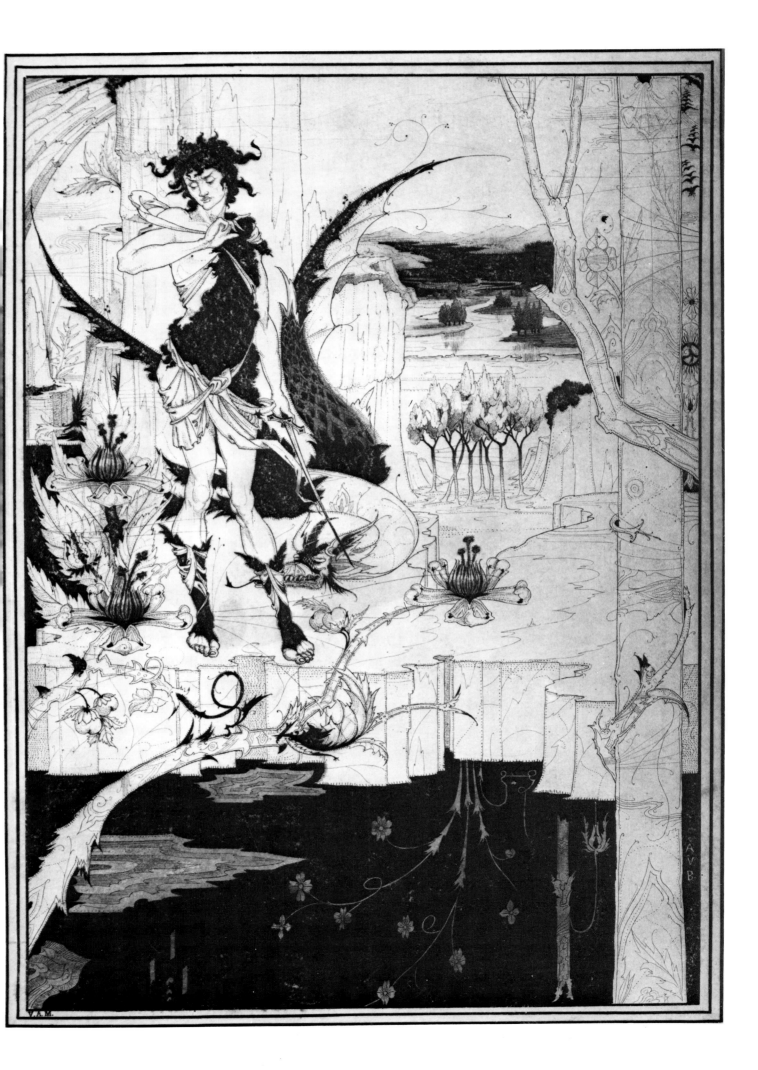

How King Arthur Saw the Questing Beast

ILLUSTRATION TO *LE MORTE DARTHUR* BY SIR THOMAS MALORY. INK AND WASH DRAWING, 38 × 27 CM. MARCH 8 1893. LONDON, THE VICTORIA AND ALBERT MUSEUM

Beardsley's name and the precise date appear at the base of the trunks of the two trees on the left of this drawing which can be seen as a companion to Siegfried. It illustrates an episode early in the story of Arthur when the King finds himself alone in the forest after chasing a stag: ' ... he set him down by a fountain, and there he fell in great thoughts. And as he sat so, he thought he heard a noise of hounds, to the sum of thirty. And with that the King saw coming toward him the strangest beast that ever he saw or heard of; so the beast went to the well and drank, and the noise was in the beast's belly like unto the questing of thirty couple hounds; but all the while the beast drank there was no noise in the beast's belly: and therewith the beast departed with a great noise whereof the king had great marvel.' (Book I. Ch. 19)

Although Beardsley's depiction of this strange encounter is fantastic, indeed bizarre, he brings it to life by the remarkable psychological realism of the suspicious looks exchanged by Arthur and the Beast. The way the Beast is carefully keeping Arthur in view out of the corner of its eye while quenching its thirst is a

particular stroke of genius. The device in the lower right corner of three vertical lines and three arrow or heart shaped forms is a signature Beardsley adopted in 1893. It is clearly inspired by Whistler's stylised butterfly signature and is said to be based on three candles and their flames. Its purpose, as that of Whistler's butterfly, is to avoid written words interfering with the pictorial purity of the composition.

The Vignette for the *Bon-Mots of Smith and Sheridan* (Fig. 13) is typical of the dozens of extraordinary if minor inventions Beardsley made for this volume and its two successors. Almost none of them have the remotest connection with the text and the term 'grotesque' used to describe them in the title pages of the books accurately sums them up. The use of the grotesque, that is of the deliberately and exaggeratedly ugly and bizarre, is a convention in art that expresses a particularly disillusioned view of life and it is an important element in a great deal of Beardsley's art. Indeed he once, famously, remarked 'I have one aim — the grotesque. If I am not grotesque I am nothing.'

Fig. 13
Vignette for *Bon-Mots* of Sydney Smith and R. Brinsley Sheridan

INK DRAWING, 5.5 × 10 CM. 1893. LONDON, THE VICTORIA AND ALBERT MUSEUM

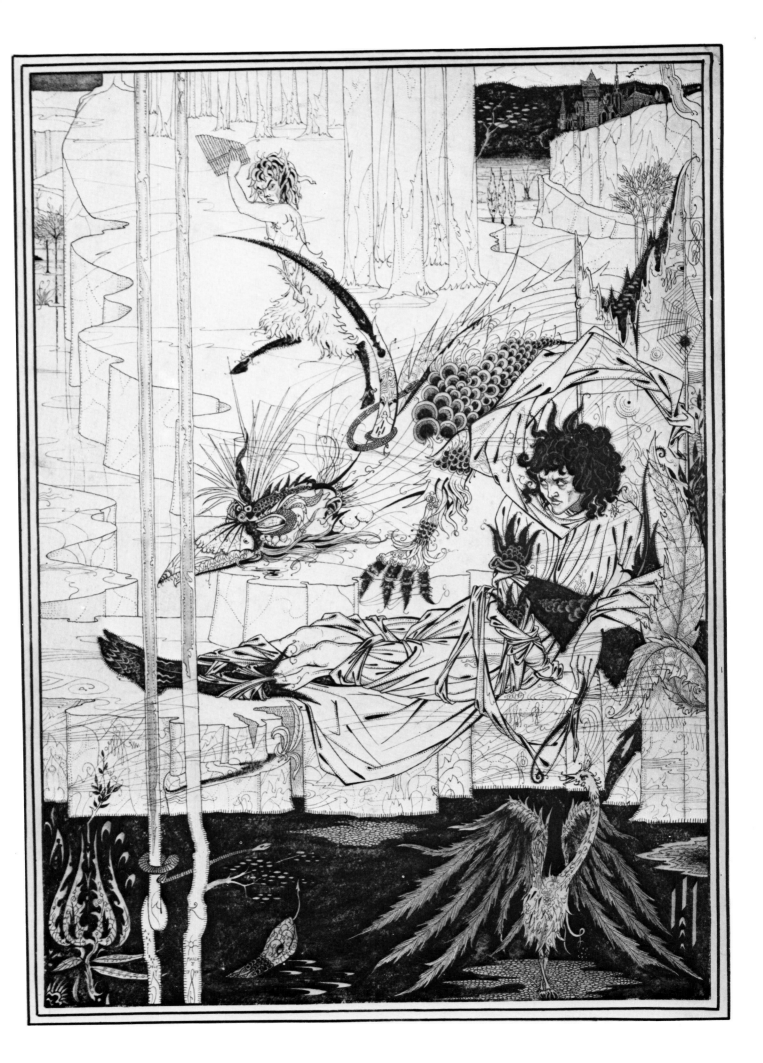

How La Beale Isoud Nursed Sir Tristram

ILLUSTRATION TO *LE MORTE DARTHUR* BY SIR THOMAS MALORY. INK DRAWING, 28 × 22 CM. 1893. CAMBRIDGE (MASS.), FOGG ART MUSEUM

Drawn probably in the late summer of 1893 this and the two plates which follow show clearly the new power and sophistication of design that Beardsley achieved at this time when he was working concurrently on *Salome* and *Le Morte Darthur*. The legend of Tristram and La Beale Isoud occupies barely one third of the first volume of *Le Morte Darthur*, yet Beardsley devoted to it no less than five of the twelve full page drawings in that volume. This is certainly because he was already fascinated by the story as elaborated into a much more intensely romantic form by Wagner in his opera *Tristan and Isolde*.

Here Beardsley illustrates the episode which begins the story of the two lovers and is the key to all that follows. Sir Tristram as champion of Cornwall has slain the Irish champion Sir Marhaus but is gravely wounded himself. He is advised that only in Ireland, where he received the wound, can it be healed. He returns, in disguise, to the court of the Irish King Anguish who receives him well and commands his daughter La Beale Isoud to heal his wound. This she does, falling deeply in love with Tristram in the process. The Irish court are not yet aware that Tristram is the killer of their champion.

Beardsley has brilliantly depicted Isoud's dawning passion as with hooded eyes she kneels beside the wounded knight and, unable to resist, tentatively lays her hand upon his thigh. Equally brilliant is the way in which this theme of passion held in check is echoed in the formal structure of the composition in which the two figures, themselves drawn with extreme economy, are firmly contained within a box-like grid of lines. In the border, however, by contrast, Beardsley has unleashed a continuous growth of flame-like tree forms, clearly expressive of the powerful natural forces gathering beneath the apparently calm surface of the lovers.

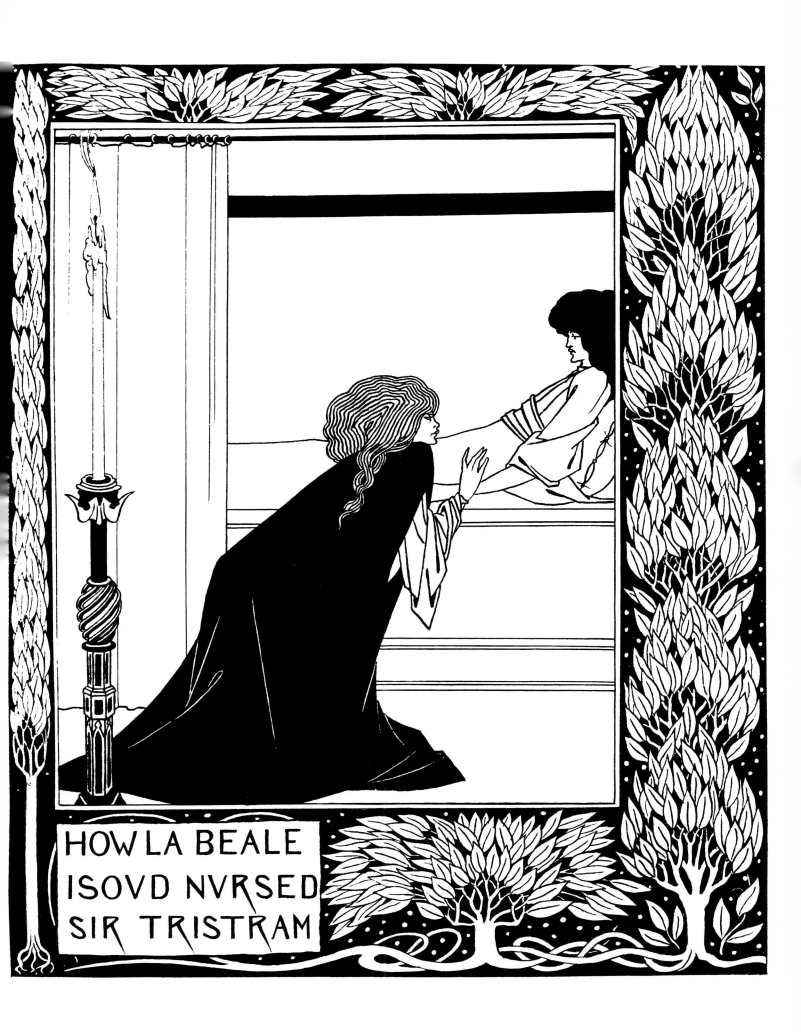

HOW LA BEALE
ISOVD NVRSED
SIR TRISTRAM

How Sir Tristram Drank of the Love Drink

ILLUSTRATION TO *LE MORTE DARTHUR* BY SIR THOMAS MALORY. INK DRAWING, 28 × 22 CM. C.1893. CAMBRIDGE (MASS.), FOGG ART MUSEUM

now no good knight no
an I may. And for th
beseech you to help m
Table, wherefore ye ou
disherited an she besoug
HOW
HELP
OF L
FROM
promis
she tha
was ho
and ba
and py
may ye rest you in this
she put off his helm and
And then he awoke and

Fig. 14
Heading for Chapter IX Book XIV of *Le Morte Darthur*

LINE BLOCK REPRODUCTION, 4.2 × 2.8 CM. 1894. TAKEN FROM THE BOOK

In this drawing Beardsley has depicted the other key scene from the story of Tristram and Isoud, the drinking of the love potion. Tristram, in spite of his love for Isoud, has arranged her marriage to his king, Mark of Cornwall, thus ending the enmity between Cornwall and Ireland. The setting of the scene is on board the ship in which Tristram is taking Isoud to Cornwall. From this point, however, there are major divergences between the story in *Le Morte Darthur* and Wagner's version, and there is no doubt that when he made this drawing Beardsley was thinking of Wagner. In Wagner the knight killed by Tristram is not merely the Irish champion but Isoud's lover. Furthermore, she discovers Tristram's real identity while nursing him and is about to kill him with his own sword when he opens his eyes and looks straight into hers. An extremely complex emotion of love and hate is then born in her. Driven by the inconsistencies of her feelings for Tristram and by despair at his apparent callousness in marrying her to King Mark, Isoud prepares a poisoned drink which she gives to Tristram before drinking it herself. Tristram, by now equally in despair, first offers her his sword to kill him, then, when she refuses, agrees to drink in symbolic atonement. He is clearly aware that the cup is poison: 'The cup that now I take will cure the hurt completely.'

Beardsley has perfectly rendered Isoud's expression of bitter triumph as she watches Tristram about to drink. Neither of them know that Isoud's faithful servant has substituted a love potion for the poison. No more intense emotion can be imagined than that of two people who, expecting mutual death, instead find passionate love. The weaving together of love and death into a single theme is one of the most powerful devices in romantic art and one that held a particularly strong appeal for Beardsley. It is also the central theme of Wilde's *Salome* (Plates 11–16, Figs. 19–21).

Fig. 14 is typical of the dozens of small drawings for chapter headings throughout *Le Morte Darthur*. Like almost all these it appears to have no connection with the text at the point where it occurs. However, when he drew it Beardsley was probably thinking of Ophelia's suicide by drowning in Shakespeare's *Hamlet*, another great example in literature of the theme of love and death.

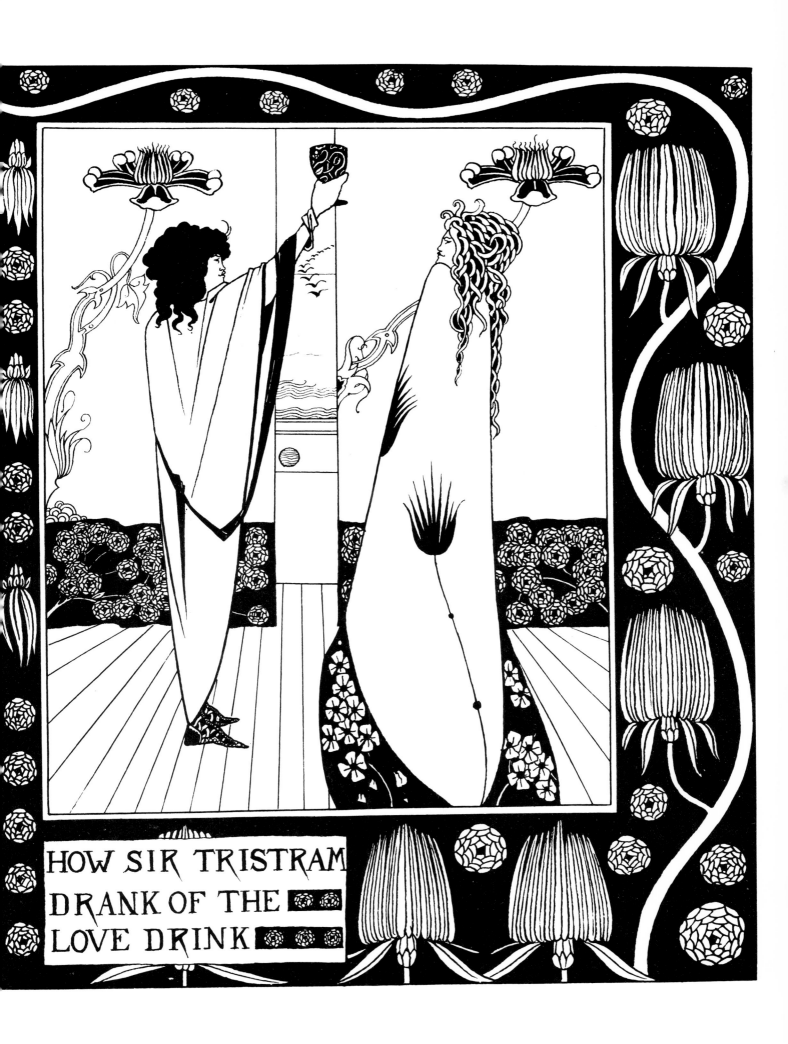

HOW SIR TRISTRAM
DRANK OF THE
LOVE DRINK

How Queen Guinever Made her a Nun

ILLUSTRATION TO *LE MORTE DARTHUR* BY SIR THOMAS MALORY. LINE BLOCK REPRODUCTION, 21 × 16 CM. 1894. TAKEN FROM THE BOOK

The last full page illustration in *Le Morte Darthur*: 'And when Queen Guinever understood that King Arthur was slain, and all the noble knights, Sir Mordred and all the remnant, then the queen stole away, and five ladies with her, and so she went to Almesbury; and there she let make herself a nun, and wore white clothes and black, and great penance she took, as ever did sinful lady in this land ...'

The explanation of her 'sinfulness' emerges when Sir Lancelot arrives by chance at the nunnery: 'When Sir Lancelot was brought to her then she said to all the ladies: Through this man and me hath all this been wrought, and the death of the most noblest knights of the world; for through our love that we have loved together is my most noble lord slain.' Beardsley has stressed Guinever's character as adulteress and *female fatale*, giving her the features of a pretty, sensual young woman and adding a sinister touch in the raven's beak silhouette of the cowl of her habit.

Merlin (Fig. 15) is the second illustration in *Le Morte Darthur*, occurring after the frontispiece, on the back of the contents page. It introduces Merlin as he first appears at the very beginning of the book dressed 'in a beggar's array.' He is found thus by Sir Ulfius who takes him to the court of Uther Pendragon. Merlin's magic enables Uther to defeat his enemy the Duke of Cornwall and take the Duke's wife Igraine, who becomes the mother of the future King Arthur. This drawing is another example of Beardsley's intense characterisation of the personages of *Le Morte Darthur*.

Fig. 15
Merlin

ILLUSTRATION TO *LE MORTE DARTHUR* BY SIR THOMAS MALORY
INK DRAWING, DIAMETER 15 CM. 1893. WASHINGTON, LIBRARY OF CONGRESS, ROSENWALD COLLECTION

Cover of *Le Morte Darthur*

GOLD STAMPED ON CREAM CLOTH, 24.5 × 19 CM. (FRONT ONLY). 1894. PRIVATE COLLECTION

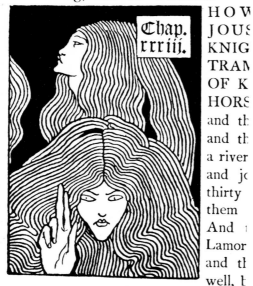

will well, said the king, that he
be friends. Then the barons se
a safe conduct. And so when
king he was welcome, and no rel
was game and play. And then tl
on hunting, and Sir Tristram.

**Chap.
xxxiii.**

HOW
JOUS
KNIG
TRAN
OF K
HORS
and th
and th
a river
and jc
thirty
them
And
Lamor
and tl
well, t

Then Sir Lamorak proffered to jou
fared so with the thirty knights tha
but that he gave him a fall, and so
I marvel, said King Mark, what
deeds of arms. Sir, said Sir Tri

Le Morte Darthur was published in 12 parts between June 1893 and November 1894 in an ordinary edition of 1500 copies at 2s 6d each and a special edition on dutch hand-made paper of 300 copies at 6s 6d each. When the issue was complete the purchaser could return the parts to the publisher for this casebinding, designed by Beardsley. The ordinary edition was put into two volumes, the hand-made paper edition into three, all in the same binding. The cost of binding was 7s 6d per volume and 8s 6d per volume respectively.

The cover for *Le Morte Darthur* is one of Beardsley's greatest single works, extraordinary in its balance of controlled elegance of composition with the lush, even sinister effect of the huge fleshy flowers and scythe-like leaves writhing their serpentine curves across its surface. The overall effect is of an expressive richness rare in the arts of design.

The cover for *Le Morte Darthur* also reminds us that by the 1890s a beautiful book cover did not necessarily have to be the laborious product of a highly-skilled craftsman. The production of finely designed bookbindings by stamping and printing on cloth or board covers had been pioneered by Dante Gabriel Rossetti and Whistler in the 1870s and reached a climax in the 1890s with contributions from many others besides Beardsley, most notably Charles Ricketts and Laurence Housman. Some of Beardsley's other book covers are reproduced in Plates 19 and 23.

Fig. 16 is one of the most memorable of all the small designs for *Le Morte Darthur*, a particularly striking demonstration of Beardsley's ability to transform the image of reality into a powerful abstract and decorative design which also remains highly expressive. These sinister and mysterious women making enigmatic signs to us are typical of many to be found in the pages of *Le Morte Darthur*.

Fig. 16
Heading for Chapter XXXIII, Book XIII of *Le Morte Darthur*

LINE BLOCK REPRODUCTION, 7.4 × 5 CM. 1893. TAKEN FROM THE BOOK

How a Devil in Woman's Likeness would have Tempted Sir Bors

ILLUSTRATION TO *LE MORTE DARTHUR* BY SIR THOMAS MALORY. INK DRAWING, EACH PANEL C.26 × 19.5 CM. 1894, THE ART INSTITUTE OF CHICAGO

An illustration to an episode in which the knight errant Sir Bors undergoes a test of character arranged for him after he allows his brother to be (as he thinks) killed while he chooses first to rescue an unknown damsel in distress, about to be ravished by a strange knight. Afterwards he meets a priest who hears his story and asks which would have been the greater harm, 'thy brother's death, or else to have suffered her to have lost her maidenhood?' A knotty problem to which Sir Bors makes no reply. The priest then introduces him into a castle where he is made much of and the beautiful lady of the castle attempts to seduce him. He resists all her considerable blandishments: 'Then she departed and went up into a high battlement, and led with her twelve gentlewomen; and when they were above, one of the gentle-women cried and said: Ah, Sir Bors, gentle knight have mercy on us all, and suffer my lady to have her will, and if ye do not we must suffer death with our lady, for to fall down off this high tower ...' Sir Bors resists even this blackmail and the ladies all duly throw themselves off the tower, to Sir Bors' momentary embarrassment. But: 'Anon he heard a great noise and a great cry, as through all the fiends in hell had been about him; and therewith he saw neither tower, nor lady, nor gentlewomen.'

Design for the Bookplate of John Lumsden Propert

INK DRAWING, 19.5 × 12.5 CM. 1893, LONDON, THE VICTORIA AND ALBERT MUSEUM

Bookplates or ex-libris (from the library of) became extremely popular in the 1890s both as a practical means of identifying a person's books and as collectors' items in their own right. This is one of a number of ex-libris by Beardsley and he evidently enjoyed doing them since they include, as here, some of his finest designs.

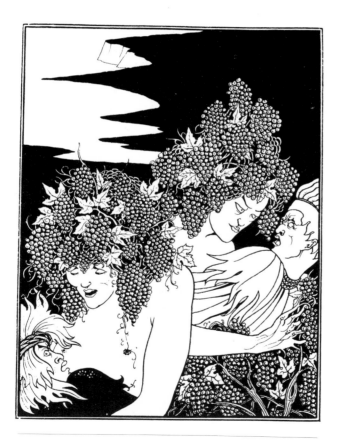

Fig. 17
A Snare of Vintage

INK DRAWING, 15 × 11 CM. 1893. VIENNA, GRAPHISCHE SAMMLUNG
ALBERTINA

The image of a young man worshipping a mysterious, sensual woman represents a fundamental Romantic and Decadent attitude, the vision of woman as a goddess of pleasure. Here the young man is dressed as Pierrot, a theatrical personage of great importance to Beardsley and other artists and poets from the eighteenth century onwards. Pierrot became a particular cult among the great Romantics, Gautier and Baudelaire prominent among them, when the part was played by the actor Jean-Gaspard Duburau from 1826 to 1846 at the Paris Théâtre des Funambules, a popular theatre that had previously been a circus. Before Duburau, Pierrot had been a simple pantomime clown but Duburau gave him a positive, complex character at once slightly satanic, innocent and tragic, someone outside the normal social world. Artists like Beardsley seem quite simply to have identified with him. Ernest Dowson's play *Pierrot of the Minute* which Beardsley illustrated is another example of this.

A Snare of Vintage (Fig. 17) is an illustration to the second-century Greek writer Lucian's *True History*, not a true history at all but a fantastic adventure that formed the model for much later stories such as *Gulliver's Travels*. Beardsley was commissioned to illustrate it in December 1892 but although it was, in his own words, 'a delightful book to illustrate', the pressure of *Le Morte Darthur* prevented him completing more than five drawings. Of those only *A Snare of Vintage* and one other were included in the edition published in 1894. *A Snare of Vintage* illustrates the episode in which Lucian and his companions come 'among a world of vines of incredible number, which towards the earth had firm stocks and of good growth; but the tops of them were women, from the hip upwards having all their proportions perfect and complete ... Some of them desired to have carnal mixture with us and two of our company were so bold as to entertain their offer, and could never afterwards be loosed from them ...' Another example of Beardsley's fascination with the theme of the *femme fatale*.

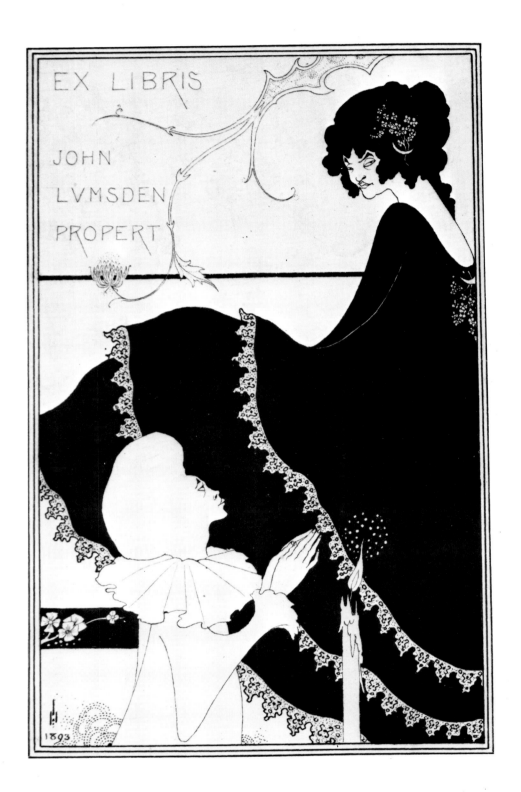

The Kiss of Judas

INK DRAWING, 31 × 22 CM. 1893, LONDON, THE VICTORIA AND ALBERT MUSEUM

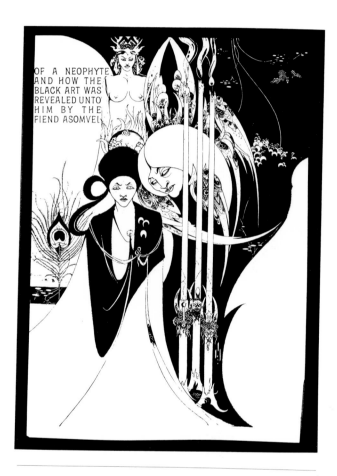

The Kiss of Judas and *Of a Neophyte* (Fig. 18), both done for the *Pall Mall* magazine, were published in the July and June 1893 issues respectively. Stylistically *Of a Neophyte* seems to be transitional in Beardsley's development from his first *Salome* illustration, *J'ai Baisé ta Bouche* (Fig. 10), to the much cleaner and more masterly manner of the main group of *Salome* drawings. *The Kiss of Judas* is wholly in that manner. Both are among Beardsley's more bizarre masterpieces. *The Kiss of Judas* illustrated a short story about '... a Moldavian legend ... They say that the children of Judas, lineal descendants of the arch traitor, are prowling about the world seeking to do harm, and that they kill you with a kiss.' *Of a Neophyte* was drawn to accompany the second of two articles on *The Black Art*. It is a splendid black magic fantasy and it is possible that Beardsley intended the joking suggestion that the neophyte is himself, and that he was taught 'the black art' — the art of black and white drawing — by a fiend.

Fig. 18
Of a Neophyte and how the Black Art was Revealed
unto Him by the Fiend Asomuel

LINE BLOCK REPRODUCTION, 23.5 × 15.5 CM. 1893

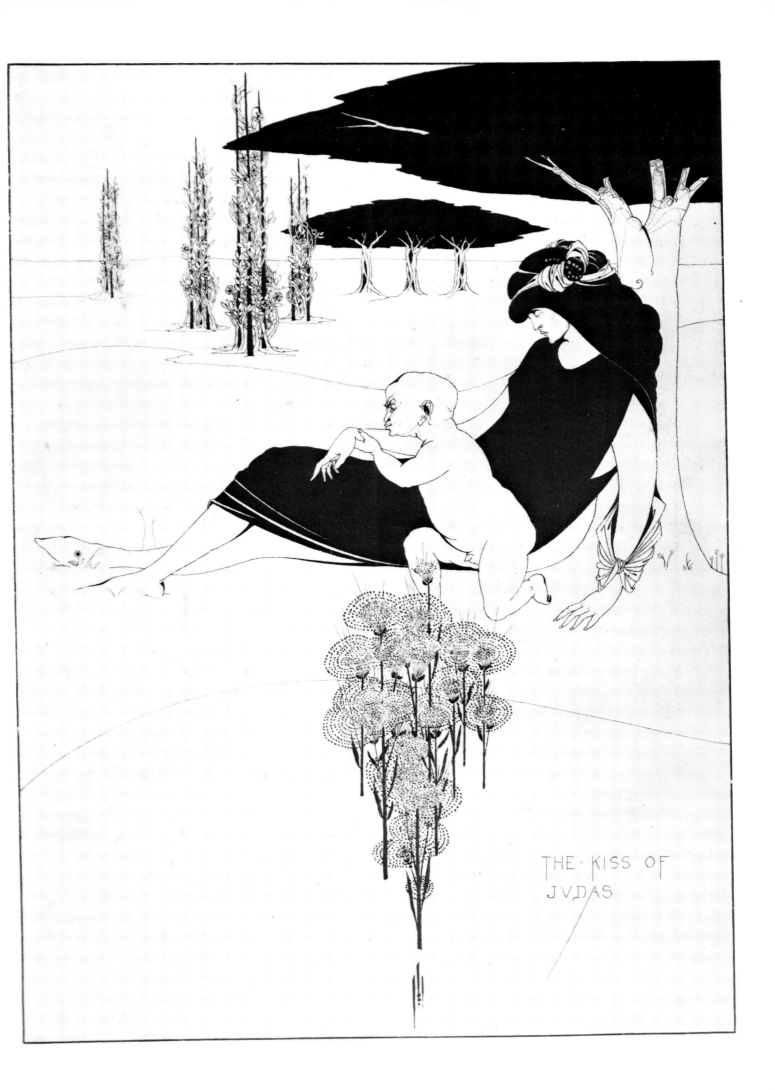

THE·KISS OF
JVDAS

The Woman in the Moon

ILLUSTRATION TO *SALOME* BY OSCAR WILDE. INK DRAWING, 22 × 15.5 CM. 1893. CAMBRIDGE (MASS.), FOGG ART MUSEUM

This has always rightly been considered one of the most perfect of all Beardsley's works, the greatest example of his ability to create powerful expressive effects with extreme economy and purity of means.

It illustrates the opening scene of Wilde's play which takes place on the terrace of Herod's palace. The young Syrian Captain of the guard, in a long cloak, is in conversation with the naked page boy of Herodias:

The Young Syrian: How beautiful is the Princess Salome tonight!

The Page of Herodias: Look at the moon! How strange the moon seems! She is like a woman rising from a tomb. She is like a dead woman. You would fancy she was looking for dead things.

Right from the beginning of the play Salome's name is thus linked with the idea of woman as an instrument or embodiment of death.

The face of the moon is a caricature of Oscar Wilde, as are the faces of Herod in *The Eyes of Herod* (Plate 12) and the master of ceremonies in *Enter Herodias* (Plate 13). The question of Beardsley's relationship with Wilde is an extremely complex one. It is clear that they did not really get on from the time they first came into close contact over the project to illustrate Salome. After Wilde's imprisonment Beardsley, not unnaturally, seems to have felt that to acknowledge a public connection with Wilde would threaten his own position. There is however evidence that after Wilde's release from prison relations between them were not as distant or embittered as has sometimes been suggested. And in the end they always had profound artistic and intellectual interests in common.

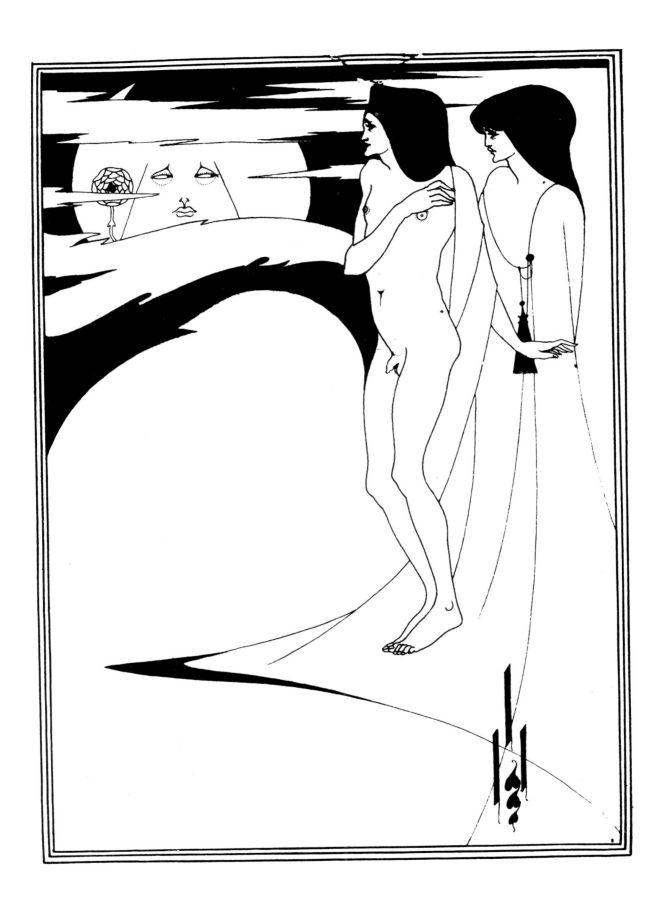

The Eyes of Herod

ILLUSTRATION TO *SALOME* BY OSCAR WILDE. INK DRAWING, 23 × 17 CM. 1893. CAMBRIDGE (MASS.), FOGG ART MUSEUM

From early in the play, Salome complains of Herod's constant looking at her with what she realises are lustful eyes: 'Why does the Tetrarch look at me all the while with his mole's eyes under his shaking eyelids? It is strange that the husband of my mother looks at me like that. I know not what it means. In truth, yes I know it.' Herodias, her mother, complains even more: 'You are looking again at my daughter. You must not look at her. I have already said so.'

Herod: You say nothing else.
Herodias: I say it again.

Beardsley expresses Herod's fatal lust through a multitude of phallic symbols: the candelabrum with its candles, held by the twin putti, the rampant peacock's head, the trees. The composition is of great decorative splendour and, in spite of its purity of line and large uncluttered spaces, has an appropriate hothouse lushness.

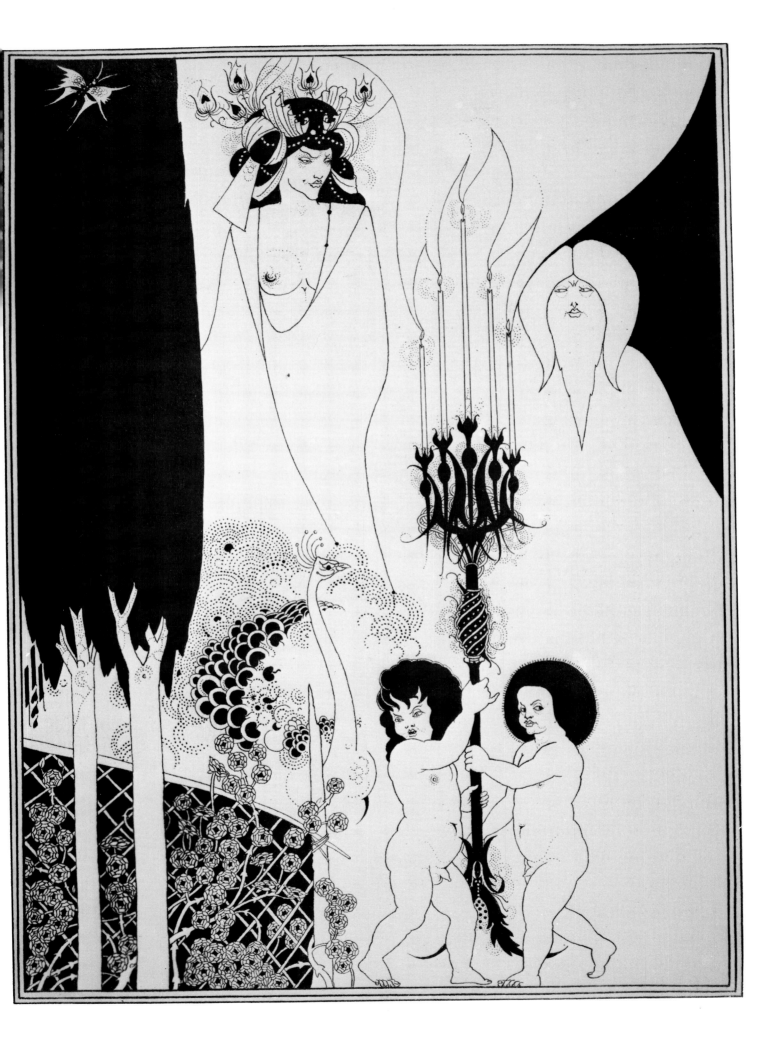

Enter Herodias

ILLUSTRATION TO *SALOME* BY OSCAR WILDE, PUBLISHED STATE. INK DRAWING, 21 × 15.5 CM. 1893. LOS ANGELES COUNTY MUSEUM OF ART

At the period of the *Salome* drawings Beardsley was at his most provocative in introducing into his work overt erotic elements that he knew would shock (non-overt, or unconscious erotic references, are virtually universal in his art as Brigid Brophy has pointed out). This caused considerable trouble with the publisher of *Salome*, John Lane, who insisted on censoring several of the *Salome* illustrations. In the case of *Enter Herodias* Lane objected to the nudity of the page boy (Fig. 19) and, as a brilliant piece of research by Mr Brian Reade has recently confirmed, Beardsley erased the offending parts from the original drawing and drew on a rather jokey fig leaf. The drawing had been photographed before alteration, a line block made and some proofs pulled. The one reproduced here was sent by Beardsley to a friend, one Alfred Lambart, inscribed:

Because one figure was undressed
This little drawing was suppressed
 It was unkind —
 But never mind
Perhaps it all was for the best.

As it happens Lane failed to notice two other provocations in his drawing: the phallic candlesticks at the lower left and the presence of an enormous phallus, jokingly placed against the candle flame, under the clothing of Herodias's strange dwarf attendant. This failure is a striking tribute to the novelty of Beardsley's style at that time.

The drawing depicts the first entrance on stage of Herodias. It is essentially a portrait of her and Beardsley has created an unforgettable image of this evil matriarch. The satanic master of ceremonies holding a copy of the play is, like the dwarf attendant, purely a figment of Beardsley's imagination and, as already mentioned, is a caricature of the play's author.

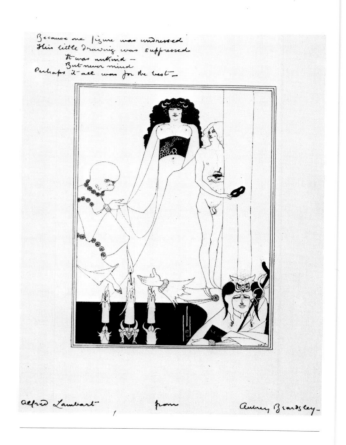

Fig. 19
Enter Herodias

ILLUSTRATION TO SALOME BY OSCAR WILDE, FIRST STATE. LINE BLOCK REPRODUCTION, 18 × 12.5 CM. 1893. PRINCETON UNIVERSITY LIBRARY

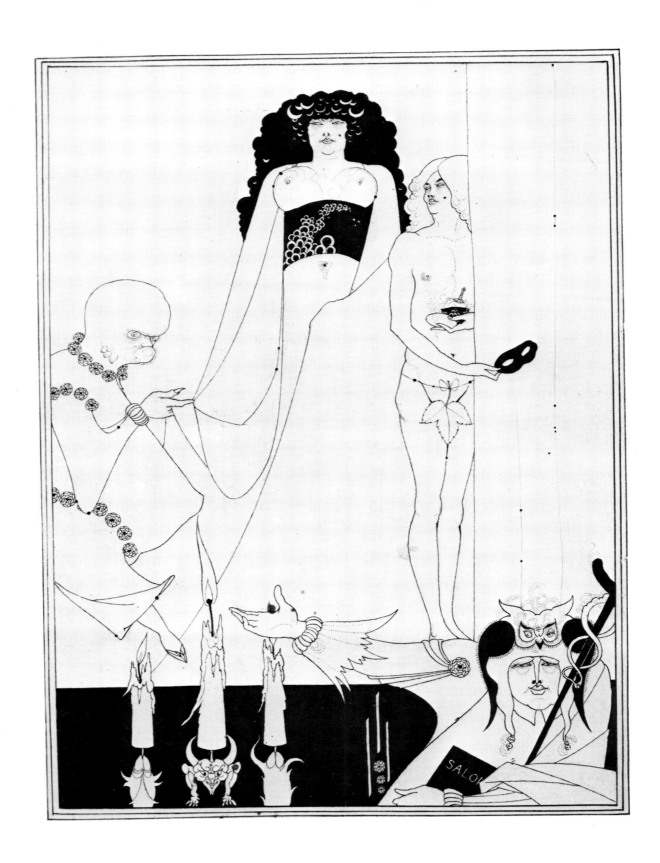

The Toilet of Salome

ILLUSTRATION TO *SALOME* BY OSCAR WILDE, SECOND VERSION. INK DRAWING, 21 × 16 CM. 1893. LONDON, THE BRITISH MUSEUM.

Beardsley's original drawing illustrating the toilet of Salome seems to have offended John Lane in so many ways that he refused to publish it. The major stumbling block was the pubic hair of the youth seated on the Japanese stool, which broke what by the nineteenth century had become an extremely rigid convention governing the depiction of the nude in art. There are other things, too, and Lane may even have taken exception to the books on the dressing-table, Baudelaire's *Les Fleurs du Mal,* one of the 'bibles' of the Decadent movement, and Zola's Realist novel *La Terre* which was considered pornographic in England (it was prosecuted in 1888). In 1898 Henry James remarked that the very name of Zola was 'a stench' in the nostrils of the English authorities.

Beardsley then made a second version of the subject which is undoubtedly a more purely beautiful drawing than the original. However, Beardsley refused to be completely defeated and the row of books on the dressing-table now includes more, and more provocative, titles than in the first version: in particular Zola's *Nana,* considered if anything even more shocking than *La Terre,* and a volume simply labelled *Marquis de Sade.*

The two versions of *The Toilet of Salome* ostensibly illustrate the scene when Salome is prepared for the dance by her slaves, as indicated by a stage direction 'Slaves bring perfumes and the seven veils, and take off the sandals of Salome.' Beardsley has used this as an excuse to elaborate entirely personal fantasies on a theme which consistently fascinated him, as it has many great artists since the Renaissance: a woman seen in the intimacy of her personal toilet.

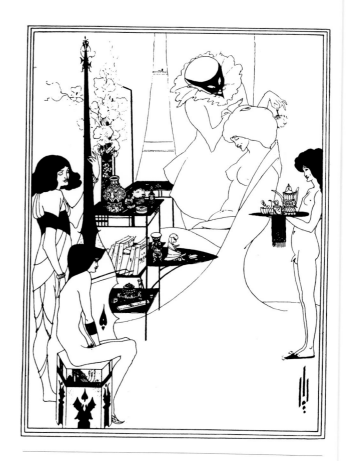

Fig. 20
The Toilet of Salome

ILLUSTRATION TO SALOME BY OSCAR WILDE, FIRST VERSION. LINE BLOCK REPRODUCTION. 23 × 16 CM. 1893.

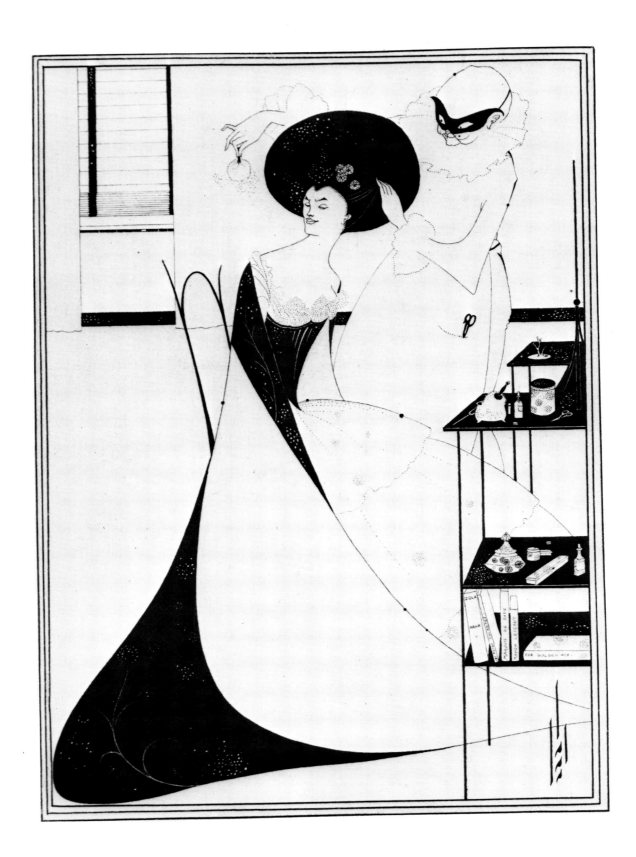

The Stomach Dance

ILLUSTRATION TO *SALOME* BY OSCAR WILDE. INK DRAWING, 22.5 × 17 CM. 1893. CAMBRIDGE (MASS.), FOGG ART MUSEUM.

This should really be called *The Dance of the Seven Veils* for that is how Salome's dance is described in the play. For reasons best known to himself Beardsley has here conceived of Salome as an oriental belly dancer although he has made a beautiful abstract pattern out of at least some of the seven veils apparently floating out from between Salome's thighs. He has also included flowers around her feet echoing Herod's anticipatory outburst in the play as he watches Salome's slaves preparing her for the dance: 'Ah, you are going to dance with naked feet. Tis well. Your little feet will be like white doves. They will be like little white flowers that dance upon the trees.'

Salome is accompanied in her dance by a musician who is another remarkable figment of Beardsley's imagination. He is also another example of a provocation that John Lane failed to notice. Careful scrutiny reveals that Beardsley has with great subtlety, but quite explicitly, depicted the effect on the musician of Salome's erotic dance.

The first of the two drawings Beardsley made illustrating the very powerful climactic scene of Wilde's play is shown in fig. 21. (For the second see Plate 16.) Salome first receives the head of John the Baptist and then, holding it up, harangues it at length, intermittently kissing it. Beardsley has more than done justice to the scene, producing two monumental and entirely relevant compositions. In *The Dancer's Reward* he takes his cue from the stage direction embodying Wilde's own powerfully dramatic concept of the executioner's arm emerging from the cistern in the ground which is the Baptist's prison:

'A huge black arm, the arm of the Executioner, comes forth from the cistern, bearing on a silver shield the head of Jokanaan. Salome seizes it.' Beardsley has brilliantly imagined Salome's expression of savage incredulity at the fulfilment of her impossible desire; she touches the blood with the tip of a finger as if to make sure it is real, that she is not dreaming.

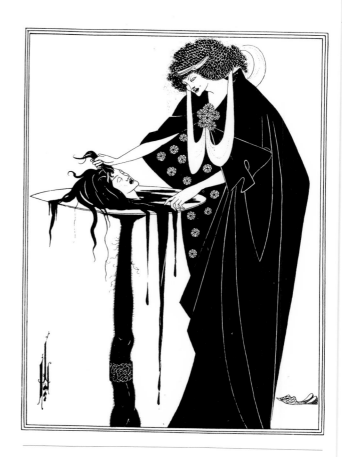

Fig. 21
The Dancer's Reward

ILLUSTRATION TO SALOME BY OSCAR WILDE. INK DRAWING, 23 × 16.5 CM. 1893. CAMBRIDGE (MASS.), FOGG ART MUSEUM

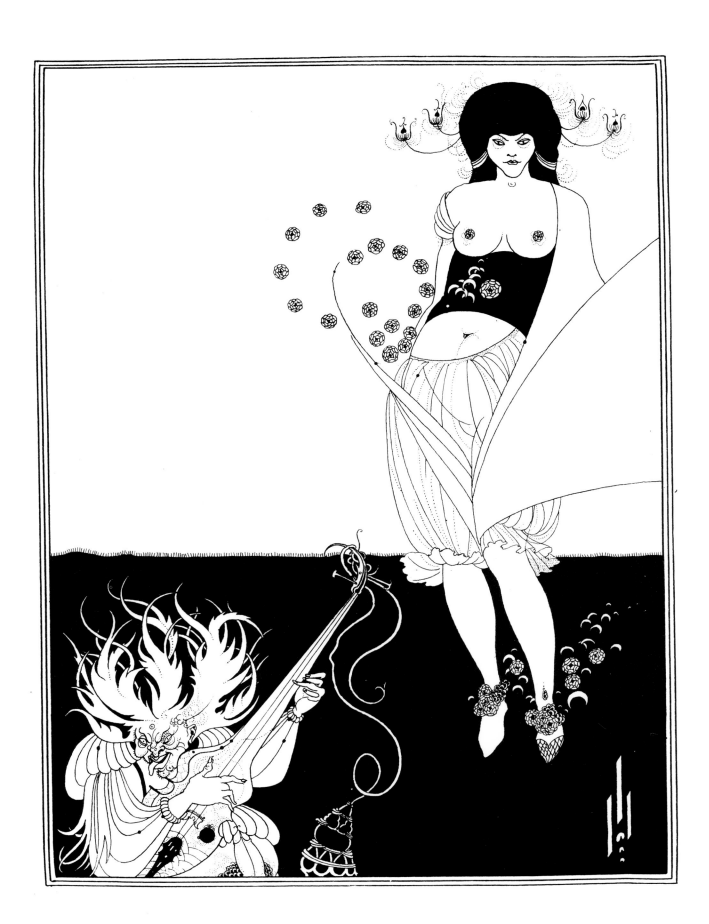

The Climax

ILLUSTRATION TO *SALOME* BY OSCAR WILDE. 35 × 27.5 CM. 1893. LINE BLOCK REPRODUCTION

As the title indicates, an illustration of the final climactic moment of *Salome* when she seizes the head of John the Baptist, and harangues it in a long, passionate and tragic speech. First she expresses triumph that he can no longer reject her advances: 'Ah! thou wouldst not suffer me to kiss thy mouth, Jokanaan. Well! I will kiss it now. I will bite it with my teeth as one bites a ripe fruit. Yes, I will kiss thy mouth Jokanaan ... Thou didst treat me as a harlot, as a wanton, me, Salome, daughter of Herodias, Princess of Judaea! Well, Jokanaan, I still live, but thou, thou art dead and thy head belongs to me ...' She then launches into a passionate prose poem of love for the Baptist: 'Ah, Jokanaan, Jokanaan thou wert the only man that I have loved ... Thy body was a column of ivory set on a silver socket. It was a garden full of doves and of silver lilies. It was a tower of silver decked with shields of ivory ... Thy voice was a censer that scattered strange perfumes and when I looked on thee I heard strange music ...' Finally she realises the horror of her position: she has killed the man she loved: 'What shall I do now Jokanaan? Neither the floods nor the great waters can quench my passion. I was a princess and thou didst scorn me. I was a virgin, and thou didst take my virginity from me. I was chaste, and thou didst fill my veins with fire ...'

Much of the power of this scene and its great appeal for Beardsley comes from the explicit emergence again of the great romantic theme of intermingled love and death. Wilde then carries the play through to its logical conclusion. Salome reiterates the words that Beardsley inscribed in their original French on his first version of this subject (Fig. 10): 'I have kissed thy mouth Jokanaan' and Herod, disgusted, gives the order 'Kill that woman!'

The stage direction that follows reads: 'The soldiers rush forward and crush beneath their shields Salome, daughter of Herodias, Princess of Judaea. CURTAIN.'

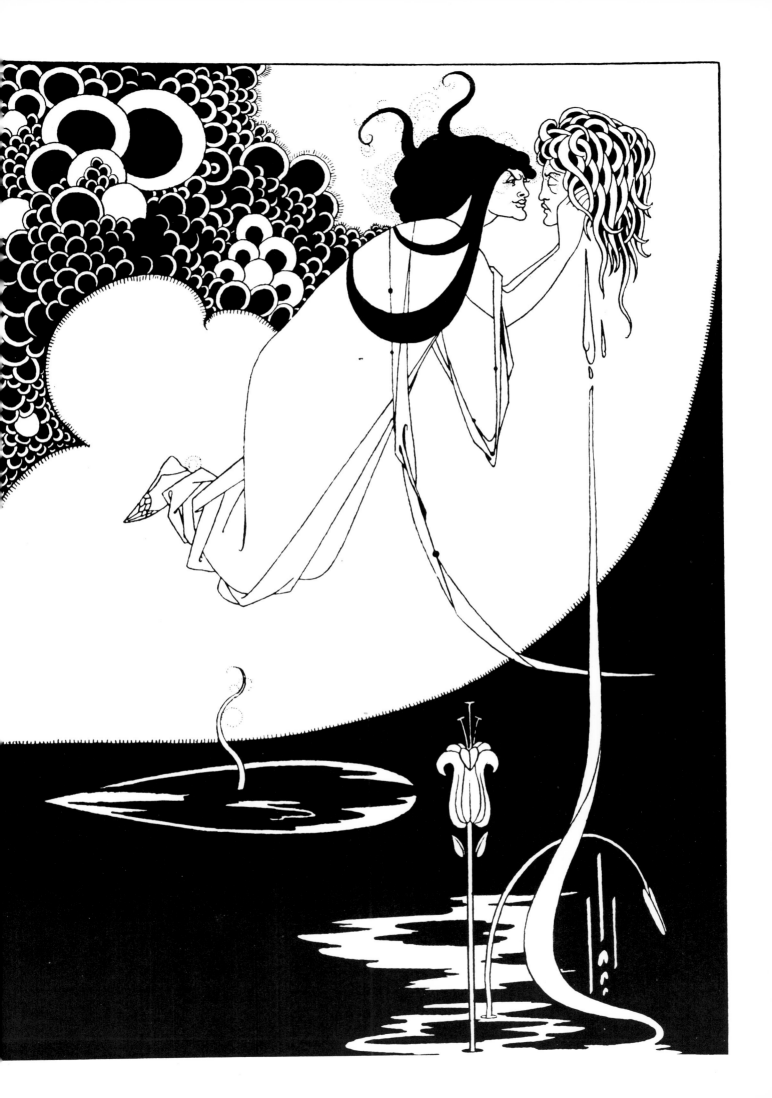

A Comedy of Sighs

POSTER ADVERTISING THE PLAY *A COMEDY OF SIGHS* AT THE AVENUE THEATRE, MARCH 1894. COLOUR LITHOGRAPH, 76 × 51 CM. 1894. LONDON, THE VICTORIA AND ALBERT MUSEUM

A boom in poster design was an important part of the overall development of design in the 1890s. It was aided by developments in lithography which permitted relatively large scale colour reproduction. The poster boom began in France with the work of Cheret, Bonnard, Lautrec and Mucha. Beardsley's poster for *A Comedy of Sighs* seems to have been among the earliest of its type in London and attracted attention, as from the paper *The Globe*: '... an ingenious piece of arrangement, attractive by its novelty and cleverly imagined. The mysterious female who looms vaguely through the transparent curtain is, however, unnecessarily repulsive in facial type ...' This poster appeared at roughly the same time as *Salome* and just before the first volume of *The Yellow Book*. It forms part of the first wave of Beardsley's art to attract wide public attention.

AVENUE THEATRE

(Licensed by the LORD CHAMBERLAIN to GEORGE PAGET, Esq.)

Northumberland Avenue, Charing Cross, W.C.

Manager - Mr. C. T. H. HELMSLEY

ON THURSDAY, March 29th, 1894,

And every Evening at 8-50,

A New and Original Comedy, in Four Acts, entitled,

A COMEDY OF SIGHS!

By JOHN TODHUNTER.

Sir Geoffrey Brandon, Bart.	Mr. BERNARD GOULD
Major Chillingworth	Mr. YORKE STEPHENS
Rev. Horace Greenwell	Mr. JAMES WELCH
Williams	Mr. LANGDON
Lady Brandon (Carmen)	Miss FLORENCE FARR
Mrs. Chillingworth	Miss VANE FEATHERSTON
Lucy Vernon	Miss ENID ERLE

Scene - THE DRAWING-ROOM AT SOUTHWOOD MANOR

Time—THE PRESENT DAY—Late August.

ACT I.	- - -	AFTER BREAKFAST
ACT II.	- - -	AFTER LUNCH
ACT III.	- - -	BEFORE DINNER
ACT IV.	- - -	AFTER DINNER

Preceded at Eight o'clock by

A New and Original Play, in One Act, entitled,

The LAND OF HEART'S DESIRE

By W. B. YEATS.

Mr. JAS. WELCH, Mr. A. E. W. MASON, & Mr. G. R. FOSS; Miss WINIFRED FRASER, Miss CHARLOTTE MORLAND, & Miss DOROTHY PAGET.

The DRESSES by NATHAN, CLAUDE, LIBERTY & Co., and BENJAMIN.
The SCENERY by W. T. HEMSLEY. The FURNITURE by HAMPDEN & SONS.

Stage Manager - - - - - Mr. G. R. FOSS

Doors open at 7-40, Commence at 8. Carriages at 11.

PRICES:—Private Boxes, £1 1s. to £4 4s. Stalls, 10s.6d.
Balcony Stalls, 7s. Dress Circle, 5s. Upper Circle (Reserved), 3s.
Pit, 2s.6d. Gallery, 1s.

On and after March 26th, the Box Office will be open Daily from 10 to 5 o'clock, and 8 till 10. Seats can be Booked by Letter, Telegram, or Telephone No. 35297.

NO FEES. NO FEES. NO FEES.

STAFFORD & CO. NETHERFIELD, NOTTINGHAM.

The Yellow Book, design for front cover of prospectus

INK DRAWING, 24 × 15.5 CM. 1894, LONDON, THE VICTORIA AND ALBERT MUSEUM

The Prospectus for *The Yellow Book* was probably in circulation by late March 1894. The drawing Beardsley did for its front cover is characteristic, as is his theatre poster (Plate 17), of the new mood of his art once he had finished with *Salome* and begun to work on *The Yellow Book,* a mood essentially of involvement with contemporary life although, as always, seen in terms of Beardsley's own particular vision. The girl in this drawing is a modern version of the depraved and sensual women from history and myth that Beardsley had so far mainly depicted. She is a *demi-mondaine* — an actress, singer, dancer, courtesan — a woman of the night, and her world is that of the theatre, the opera, the Café Royal and the streets of London's West End. Beardsley's work of the *Yellow Book* phase can be seen as having some parallels with Henri de Toulouse-Lautrec's contemporaneous depictions of the Paris *demi-monde*.

A Night Piece is one of the drawings reproduced in *The Yellow Book* Volume One. Like the drawing for *The Yellow Book* prospectus it is typical of the images of dubious ladies in the London streets, cafés or theatres at night that Beardsley seems to have delighted in at this time. The setting is said to represent Leicester Square.

Fig. 22
A Night Piece

INK DRAWING WITH TONAL WASHES, 32 × 15.5 CM. 1894. CAMBRIDGE, FITZWILLIAM MUSEUM

THE YELLOW BOOK

AN ILLVSTRATED QVARTERLY.

PRICE FIVE SHILLINGS

ELKIN MATHEWS AND JOHN LANE, THE BODLEY HEAD VIGO ST. LONDON.

APRIL 15th MDCCC XCIV.

Covers of *The Yellow Book* Volumes One and Two

LINE BLOCK PRINTED ON CLOTH, EACH 21 × 15.5 CM. 1894.

In early January 1894 Beardsley wrote to his friend Robert Ross: 'I am sure you will be vastly interested to hear that Harland and myself are about to start a new literary and artistic Quarterly. The title has already been registered at Stationers Hall and on the scroll of fame. It is THE YELLOW BOOK. In general get-up it will look like the ordinary French novel.' Ordinary French novels were at the time bound simply in bright yellow paper. There is no doubt that Beardsley, and perhaps to a lesser extent Harland, wanted *The Yellow Book* to be, in Beardsley's phrase, 'a little risqué.' The fact is, however, that except for Beardsley and his friend Max Beerbohm, the majority of contributors were highly respectable: the first two items in Volume One, after Beardsley's cover and title page, were a drawing by the President of the Royal Academy, Lord Leighton, and a story by Henry James. It was almost solely Beardsley's contributions that caused the outraged reaction of the press: *The Times* referred to the 'repulsiveness and

insolence' of the cover and went on to speak of 'a combination of English rowdyism and French lubricity,' while it was of *Mrs Patrick Campbell* (Fig. 23) and *L'Education Sentimentale* (Plate 20) that the Westminster Gazette made its famous remark about 'a short act of Parliament to make this kind of thing illegal.'

It is now difficult to understand why Beardsley's accomplished and apparently restrained caricature of the well-known actress Mrs Patrick Campbell was found so offensive. It seems to have been partly due to the sheer economy of the drawing, and the extremely ephemeral appearance given her, which led one reviewer sarcastically to complain that the portrait was absent from his copy of *The Yellow Book*. To Beardsley's protest the editor replied: 'Our own copy it is true, contained a female figure in the space thus described, but we rated Mrs Patrick Campbell's appearance and Mr Beardsley's talent far too high to suppose that they were united on this occasion.'

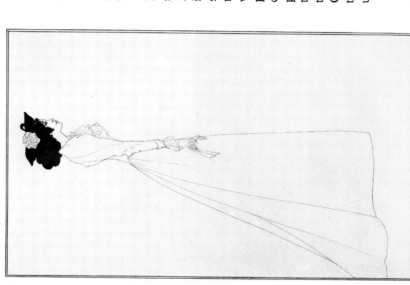

Fig. 23
Mrs Patrick Campbell

INK DRAWING, 33 × 21 CM. 1894. BERLIN,
KUPFERSTICHKABINETT

The Yellow Book

An Illustrated Quarterly

Volume II July 1894

London: Elkin Mathews & John Lane
Boston: Copeland & Day

Price 5/- Net

The Yellow Book

An Illustrated Quarterly

Volume I April 1894

London: Elkin Mathews & John Lane
Boston: Copeland & Day

Price 5/- Net

L'Education Sentimentale, fragment

INK DRAWING WITH WATERCOLOUR, 27 × 9 CM. 1894. CAMBRIDGE (MASS.), FOGG ART MUSEUM

For reasons that are not known Beardsley divided this drawing into two and, as he did with some others, worked on it with watercolour, in this case pink and green. Only the left hand portion has survived. Said to be inspired by Flaubert's famous novel, this drawing caused a shock to reviewers of *The Yellow Book* much more understandable than in the case of *Mrs Campbell*. Its theme is evidently the corruption of youth by experience, although close study of the girl suggests that she is already far from innocent. The old woman is a masterly study of a human type, and it is possible that Beardsley divided the drawing because he simply felt she would serve him better standing alone.

Fig. 24
L'Education Sentimentale

HALFTONE REPRODUCTION FROM THE YELLOW BOOK, VOLUME
ONE. 18 × 11 CM. 1894.

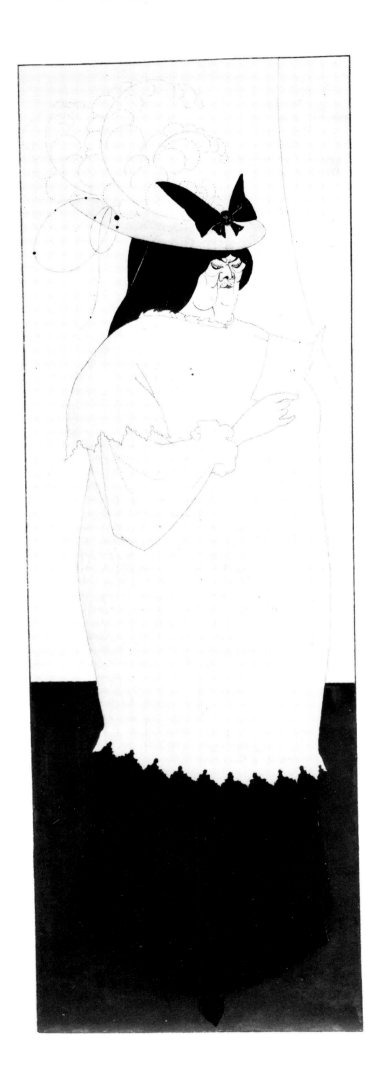

The Fat Woman

INK DRAWING, 18 × 16 CM. 1894. LONDON, THE TATE GALLERY

Classically ordered in composition, monumental in effect in spite of its small scale, profound in its depiction of human character, this is one of Beardsley's greatest drawings of any period of his career. It shows a woman sitting at a café table, almost certainly the Café Royal in London, then a favourite and famous haunt of artists and writers. She is a marvellous example of the *demi-mondaines* who people Beardsley's art at this time. She is also a caricature portrait of Whistler's wife, another of Beardsley's digs at the great artist who was once his hero.

The drawing was intended by Beardsley for inclusion in *The Yellow Book* Volume One but John Lane, the publisher, recognising its subject, refused to allow it, prompting a famous and highly disingenuous letter from Beardsley: 'Yes my dear Lane, I shall most assuredly commit suicide if the *Fat Woman* does not appear in No 1 of *The Yellow Book*. I have shown it to all sorts and conditions of men — and women. All agree that it is one of my best efforts and extremely witty. Really I am sure you have nothing to fear. I shouldn't press the matter a second if I thought it would give offence. The block is such a capital one too, and looks so distinguished. The picture shall be called *A Study in Major Lines*.' This title is the giveaway of Beardsley's real intentions since it is an obvious parody of Whistler's 'musical' titles. Lane stood fast, but the drawing was eventually published in the magazine *To-Day* in May 1894 and Whistler was offended.

Woman in Café was published in the third of the little volumes of *Bon-Mots* illustrated by Beardsley for J.M. Dent, the publisher of *Le Morte Darthur*. This volume, *Bon-Mots of Samuel Foote and Theodore Hooke*, appeared in 1894 and the drawing may date from late 1893 or early 1894. It is certainly among the earliest in Beardsley's *Yellow Book* manner and is clearly a direct ancestor of the later *Fat Woman*.

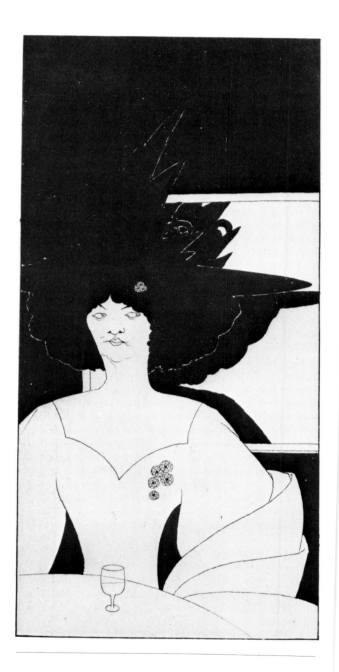

Fig. 25
Woman in Café *or* Waiting

INK DRAWING, 19.5 × 9 CM. 1893–4. LONDON, COURTESY OF MR BRIAN READE

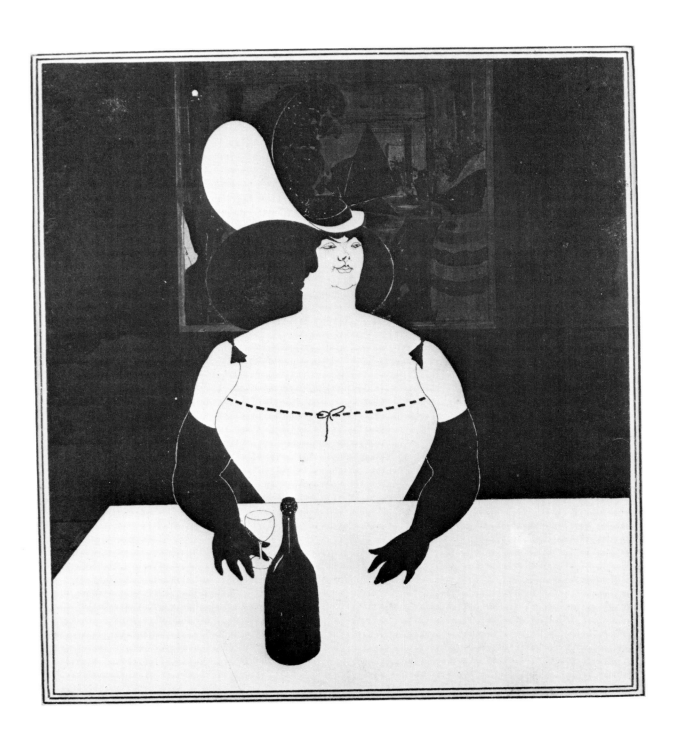

The Wagnerites

INK DRAWING TOUCHED WITH WHITE, 20.5 × 18 CM. 1894. LONDON, THE VICTORIA AND ALBERT MUSEUM

On the evidence of Beardsley's letters there were seasons of Wagner opera in London in 1892, 1894, 1895, 1896 and 1897, all of which he eagerly attended except for the one in 1896 when he was at The Spread Eagle hotel in Epsom making the drawings for *Lysistrata* (Plates 35-38). Wagnerite was the term coined to describe those who today would be called Wagner fans.

The Wagnerites is one of the numerous night-life pieces Beardsley made during the *Yellow Book* period 1894-5 in which, in a reversal of his previous practice, he conjures up form with small areas of white set in great masses of black. These drawings have always been admired for the technical skill with which Beardsley obtained the whites, even the finest lines, simply by leaving the paper free of ink. The Wagnerites is one of the very few in which he has also used some touching with chinese white. The strange, not to say bizarre, audience, composed entirely of depraved-looking, rather ugly women surrounding a single insignificant little man, has always given rise to speculation about the meaning of this drawing. It seems likely that Beardsley was satirising those wealthy and worldly opera goers for whom the opera is simply another part of the fashionable social round and who have no true interest in, or understanding of, the music. This interpretation would be pointed up, as Brian Reade has suggested, by the fact that the opera in question is, as Beardsley deliberately indicates, *Tristan und Isolde* which, in its extreme romantic idealism, of all Wagner's operas could not form a greater contrast with the grossness of this audience. With such a view of the drawing, Beardsley's labelling of these people as 'Wagnerites' becomes heavily ironic.

The Wagnerites was published in *The Yellow Book* Volume Three. On the back of the original drawing is an inscription by Joseph Pennell: 'One of the finest drawings A.B. ever made.'

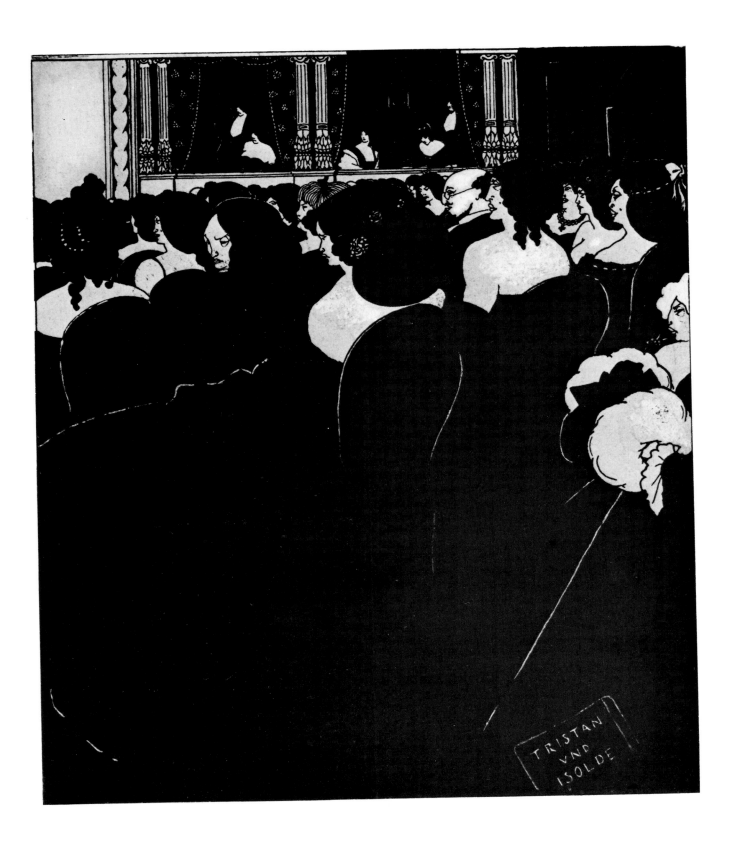

Covers of two volumes of the Keynotes series

LINE BLOCK PRINTED ON CLOTH, EACH 20 × 12 CM. BOTH PUBLISHED 1894, PRIVATE COLLECTION

Keynotes was a series of 34 novels and volumes of short stories by young writers published by John Lane from 1893. They were published quite cheaply at 3s 6d and the aim of the series was to make contemporary fiction available to a wide audience. For 22 of them Beardsley designed a cover, also used as a title page, and for 15 of them he designed an ornamental key embodying the author's initials which was reproduced on the spine and back cover of the book. The title of the series, as well as a number of the titles of individual volumes, such as *The Mirror of Music*, reflects the avant-garde association of music with the other arts so common at this period. Beardsley seems to have been particularly inspired by *The Mirror of Music* since it is one of the most elaborate designs in the series. As already explained in the note to Plate 7 there was a great blossoming of beautifully designed, printed or stamped book covers in the 1890s. Beardsley's Keynotes books were particularly significant in this context since their cheapness brought good design to a new, wider level of circulation.

A Nocturne of Chopin (Fig. 26) was intended for publication in the ill-fated fifth volume of *The Yellow Book* and was therefore probably drawn about March 1895. It is among the earliest of a number of very beautiful drawings Beardsley made, employing washes to create a very subtle range of tones rather than the pure black and white he habitually used. It shows the continuing influence of Whistler, who always worked in tone and who called many of his pictures *Nocturnes*, on Beardsley's concept of art and is presumably an attempt to represent pictorially the mood of a Chopin Nocturne.

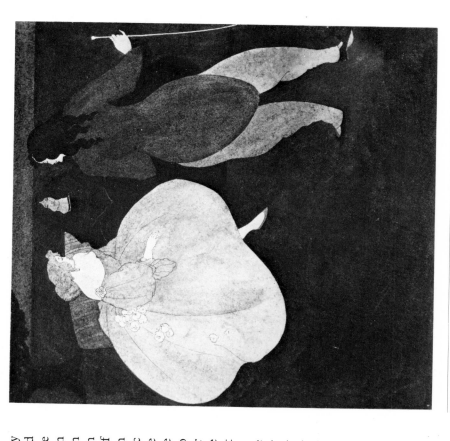

Fig. 26
Frontispiece Design for Chopin's *Nocturnes*

INK DRAWING WITH TONAL WASHES, 20 × 18.5 CM. 1895. CAMBRIDGE (MASS.), FOGG ART

The Mirror of Music

Stanley V. Makower

The Mountain Lovers

Fiona Macleod

Frontispiece design for *Plays* by John Davidson

INK DRAWING, 28.5 × 18.5 CM. 1894. LONDON, THE TATE GALLERY

John Davidson was a prominent 'minor' poet, novelist and playwright of the 1890s (*see also* Plate 27). This frontispiece was drawn for a volume of his plays published by John Lane in 1894. Like *The Fat Woman* and *The Wagnerites* it is an example of the extraordinarily bold and monumental effects Beardsley could achieve in his black-in-white compositions of the *Yellow Book* period. Not least remarkable is the way Beardsley has created the formal landscape in which the figures stand by the deployment of three simple areas of white in a uniform field of black. The lake in the background in particular is a supreme example of Beardsley's ability to create powerful abstract and decorative shapes which nevertheless retain a clear figurative significance.

The drawing ostensibly relates to the last play in the volume, a pantomime called *Scaramouche in Naxos*. Beardsley no doubt chose it because he was fascinated by pantomime and the character of Pierrot. However, as so often, he has made it the vehicle of his own vision and these fantastic pantomime characters standing in the formal landscape are all caricature portraits. Who they are, and what precisely they are doing remains partly a mystery. Some of the story is well known: on 1 March 1894 *The Daily Chronicle* published an unfavourable mention of the frontispiece. The next day they published the following letter from Beardsley: 'Sir, In your review of Mr. Davidson's *Plays* I find myself convicted of an error of taste, for having introduced portraits into my frontispiece to that book. I cannot help feeling that your reviewer is unduly severe. One of the gentlemen who form part of my decoration is surely beautiful enough to stand the test even of portraiture, the other owes me half a crown..'

This last reference is to Sir Augustus Harris, the Manager of Covent Garden, who can be firmly identified as the central bearded figure in evening dress. Beardsley caricatured him here after suffering from his apparent habit of overselling the house at Covent Garden; Beardsley had paid half a crown for a seat that was already occupied. The other firm identification is of the man in a leopard skin with clusters of grapes in his hair. This is another of Beardsley's caricatures of Oscar Wilde. The nude girl next to him was tentatively identified by the Beardsley scholar R.A. Walker as Beardsley's sister Mabel but this remains uncertain. The significance of the grouping of Wilde with a nude girl, whether Mabel or not, and of the Wilde figure having its feet bound together has been the subject of much speculation of a psycho-sexual kind. The faun in the left foreground has been identified as Henry Harland, co-editor of *The Yellow Book*, but Brian Reade thinks it could be a self-portrait of Beardsley. The masked figure in the background has been said to represent the 1890s poet Richard Le Gallienne and the dancer on the right Adeline Genée. Neither of these identifications now seems at all certain.

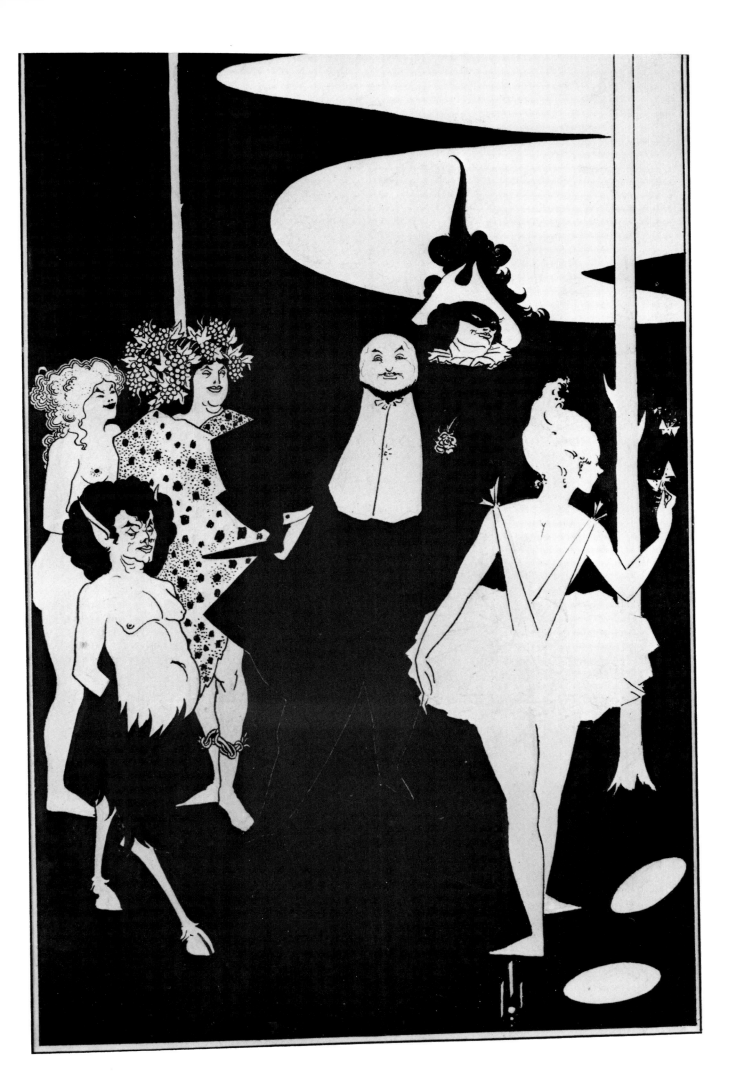

The Mysterious Rose Garden

INK DRAWING, 22 × 12.5 CM. 1894. CAMBRIDGE (MASS.), FOGG ART MUSEUM

The Mysterious Rose Garden was published in *The Yellow Book* Volume Four, January 1895, and must have been drawn late in 1894. In his 'List of Drawings by Aubrey Beardsley' published in 1909 Aymer Vallance descibes this as 'a burlesque Annunciation'. It certainly is a version of that traditional subject. But to see it simply as a parody or burlesque is to take much too superficial a view of it. Beardsley has here reworked an important and powerful traditional image to give it a fresh significance. His drawing represents the initiation or passage of youth into maturity, the supernatural messenger revealing to the innocent girl the knowledge of good and evil.

A strong pastoral vein, of a highly poetic and artificial rather than naturalistic kind, runs through Beardsley's art and appears particularly strongly in certain drawings of 1895, such as his cover design for Volume Five of *The Yellow Book*, never used (Fig. 27). It is a gentle, more lyrical version of *The Mysterious Rose Garden*, a creature from pagan mythology communicating with an innocent girl. The image is here given a particular piquancy by the complete naturalness with which Beardsley juxtaposes the goat-legged faun and the thoroughly modern young girl.

Fig. 27
Cover design for *The Yellow Book*, Volume Five

INK DRAWING, 20.5 × 15.5 CM. 1895. BRIGHTON, MUSEUM AND ART GALLERY

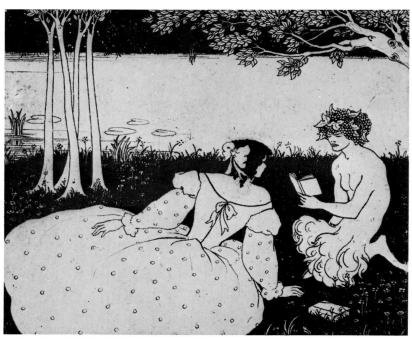

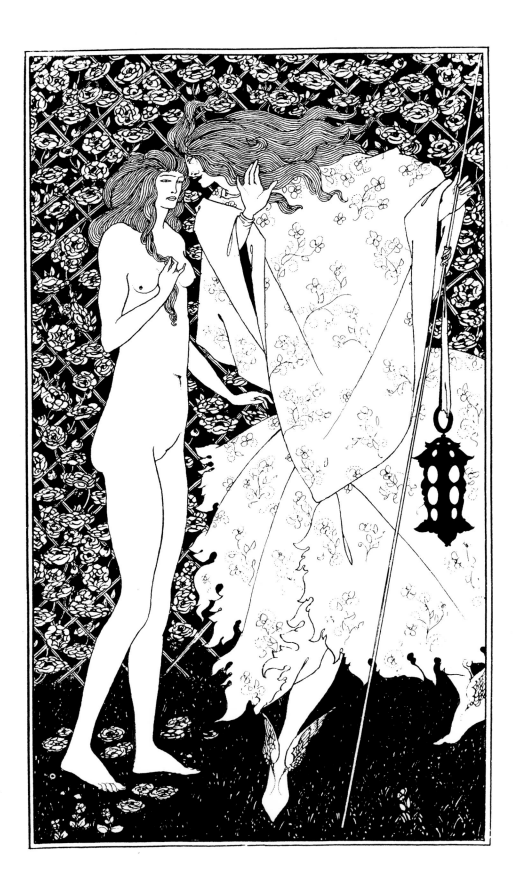

The Black Cat

ILLUSTRATION TO THE WORKS OF EDGAR ALLEN POE. INK DRAWING, 25 × 16 CM. 1894. NEW YORK, COURTESY OF MR ALBERT REESE

In a letter of 2 January 1894 Beardsley wrote to the American publishers Stone and Kimball of Chicago: 'I feel that Poe's tales would give me an admirable chance for picture making and I am sure I could do something that would satisfy us both.' He proposed to do eight drawings for which he asked £5 each. In the event he did only four which were published by Stone and Kimball in 1895. *The Black Cat* is certainly the most striking. Formally it is another remarkable example of Beardsley's extreme virtuosity at this period in creating a black image on a black ground, but the real compositional masterstroke lies in the stark opposition of the densely black cat and background and the pure white of the woman's face, a contrast compounded by a brilliant reversal of technique between the two from white in black to black on white. The dead whiteness of the woman's face has an absolutely literal expressive function too since she is in fact dead.

Poe's story of *The Black Cat* is one of his most horrific and cynical moral tales. At the beginning the narrator, a great animal lover, is living happily with his wife and numerous pets including a beautiful black cat called Pluto. However, he becomes alcoholic and one night in a drunken frenzy turns on the cat and puts out one of its eyes. The cat recovers but its reproachful presence becomes intolerable and he kills it. Subsequently in a tavern he finds another black cat, strangely similar to Pluto in having only one eye. He takes it home but its resemblance to Pluto produces increasing feelings of guilt and he attempts to kill it. His wife interferes and in a rage he kills her and walls up the body in the cellar of his house. The cat disappears. Four days later the police call. They search the house and find nothing. Just as they are about to leave the cellar, the narrator, in 'a frenzy of bravado', bangs on the wall to show how solid it is but to his horror is answered by a 'long loud and continuous scream.' The police take down the wall and reveal the corpse: 'Upon its head, with red extended mouth and solitary eye of fire, sat the hideous beast whose craft had seduced me into murder and whose informing voice had consigned me to the hangman. I had walled the monster up within the tomb!'

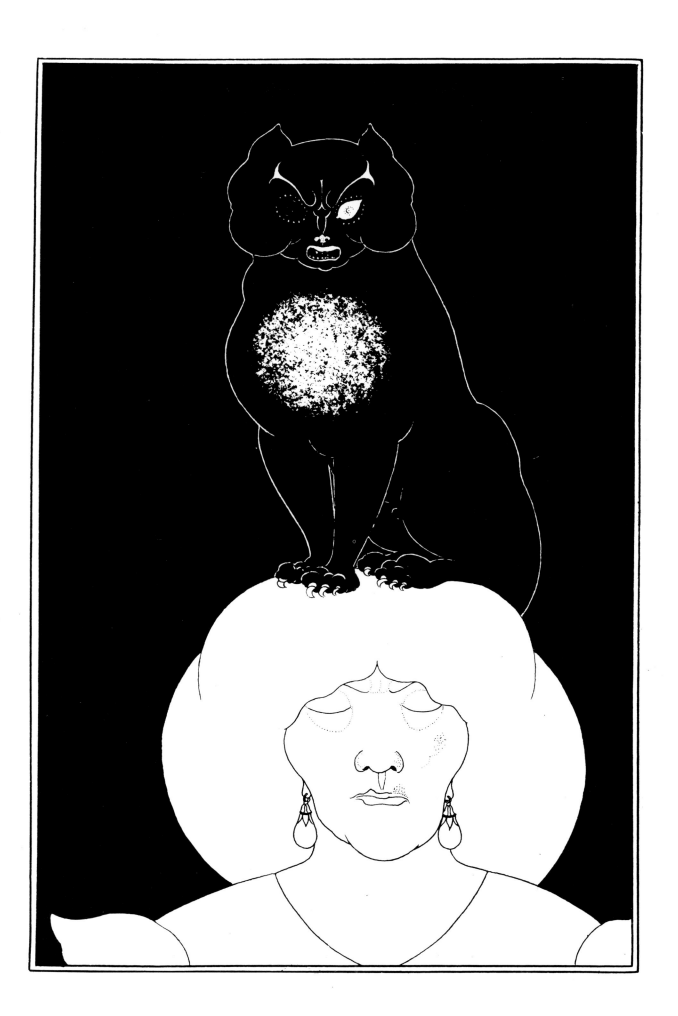

Frontispiece design for *Earl Lavender* by John Davidson

INK DRAWING, 26 × 15.5 CM. 1895. CAMBRIDGE (MASS.), FOGG ART MUSEUM

John Davidson's *Earl Lavender* is a rather odd satirical novel dealing with Darwinian evolution and the religious practice of flagellation. The eponymous hero, believing himself to be a perfect product of evolution, sets out to convert London to evolutionism. He meets a mysterious Veiled Lady who takes him to the underground quarters of a secret society of flagellants. In his preface to the book Davidson stresses that this exists as a form of atonement for the effete upper classes: 'The Flagellant Society to which the Lady of the Veil introduced Earl Lavender may therefore be taken as a sign of the times — a sign of an age of effete ideals. At least, the existence of such a sect among the wealthy classes is a proof of the existence of widespread contempt of the great commonplaces of life — love, marriage and the rearing of children. In this some will not be slow to detect the results of long-continued leisure and luxury; and, indeed, when a class is exempt for gener-

ations from suffering and toil ... it is not to be wondered at that men and women forced by circumstances into an unnatural life of ease, should rebel against everything natural.'

He is here also certainly hinting, as he does in the text, at the aspect of flagellation as erotic vice. On arrival at the Flagellant Society Earl Lavender is beaten by and in return then beats a young woman of 'great beauty' whom he afterwards realises must be the Veiled Lady. It is of her that Beardsley has drawn his picture, clearly inspired by the description of her in the text: 'Earl Lavender had no difficulty in recognising her as the robed beauty with whom he had just exchanged whippings. It was the individuality of her carriage, along with her unusual height, which betrayed her. All her motions were rapid, graceful and full of precision without being precise; and when she was at rest her stillness was like that of a statue — of Galatea wakening into life ...'

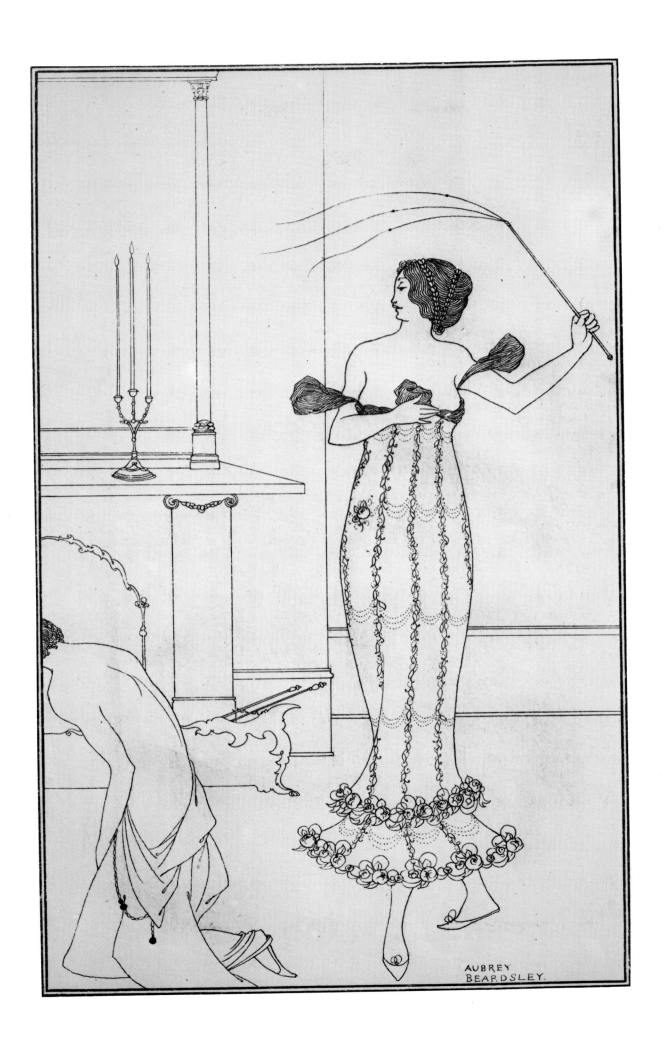

The Abbé

INK DRAWING, 25 × 17.5 CM. 1895. LONDON, THE VICTORIA AND ALBERT MUSEUM

The Abbé is the most splendid of the illustrations Beardsley made for his 'romantic novel' *Under the Hill* in the new rococo style he developed in late 1895. Originally called *The Story of Venus and Tannhäuser* Beardsley changed the title of his novel for publication in *The Savoy* because theoretically John Lane was still planning to publish it. He also changed the name of the principal character from Tannhäuser to the delightful eighteenth-century-sounding Abbé Fanfreluche. However, in the original and surviving manuscript, Tannhäuser/Fanfreluche also appears as the Abbé Aubrey which suggests that Beardsley identified himself with the character of Tannhäuser. Certainly all commentators on Beardsley have agreed on seeing this drawing as in some sense a fanciful self-portrait. As such it reminds us that Beardsley, like many of the great Romantics and Decadents from Gautier and Baudelaire to Whistler and Wilde, was a tremendous dandy, as can be seen from the marvellous portrait of him by Jacques-Emile Blanche in the National Portrait Gallery, London (Fig. 28)

The significance of dandyism for poets and artists is summarised in Baudelaire's famous comment 'on ne se pare que pour se separer,' roughly (the brilliant word play is untranslateable) 'one dresses up only to separate oneself' and Wilde's epigram 'one should either wear a work of art or be a work of art.' By dressing beautifully the romantic artist becomes himself a work of art, separate from the utilitarian everyday world.

The drawing illustrates the opening paragraphs of *Under The Hill*: 'The Abbé Fanfreluche, having lighted off his horse, stood doubtfully for a moment beneath the ombre gateway of the mysterious Hill, troubled with an exquisite fear lest a day's travel should have too cruelly undone the laboured niceness of his dress. His hand, slim and gracious as La Marquise du Deffand's in the drawing by Carmontelle, played nervously about the gold hair that fell upon his shoulders like a finely-curled peruke, and from point to point of a precise toilet the fingers wandered, quelling the little mutinies of cravat and ruffle.

'It was taper-time; when the tired earth puts on its cloak of mists and shadows, when the enchanted woods are stirred with light footfalls and slender voices of the fairies, when all the air is full of delicate

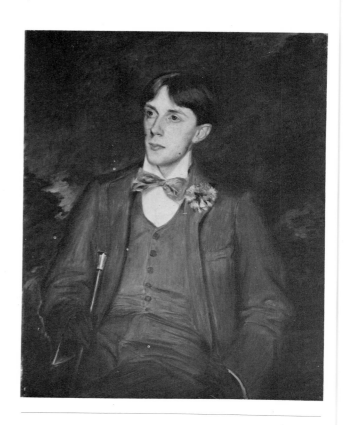

Fig. 28
Jacques-Emile Blanche
Portrait of Beardsley

CANVAS, 90 × 72 CM. 1895. LONDON, THE NATIONAL PORTRAIT GALLERY

influences, and even the beaux, seated at their dressing-tables, dream a little.

'A delicious moment, thought Fanfreluche, to slip into exile.

'The place where he stood waved drowsily with strange flowers, heavy with perfume, dripping with odours. Gloomy and nameless weeds not to be found in Mentzelius. Huge moths, so richly winged they must have banqueted upon tapestries and royal stuffs, slept on the pillars that flanked either side of the gateway, and the eyes of all the moths remained open and were burning and bursting with a mesh of veins.'

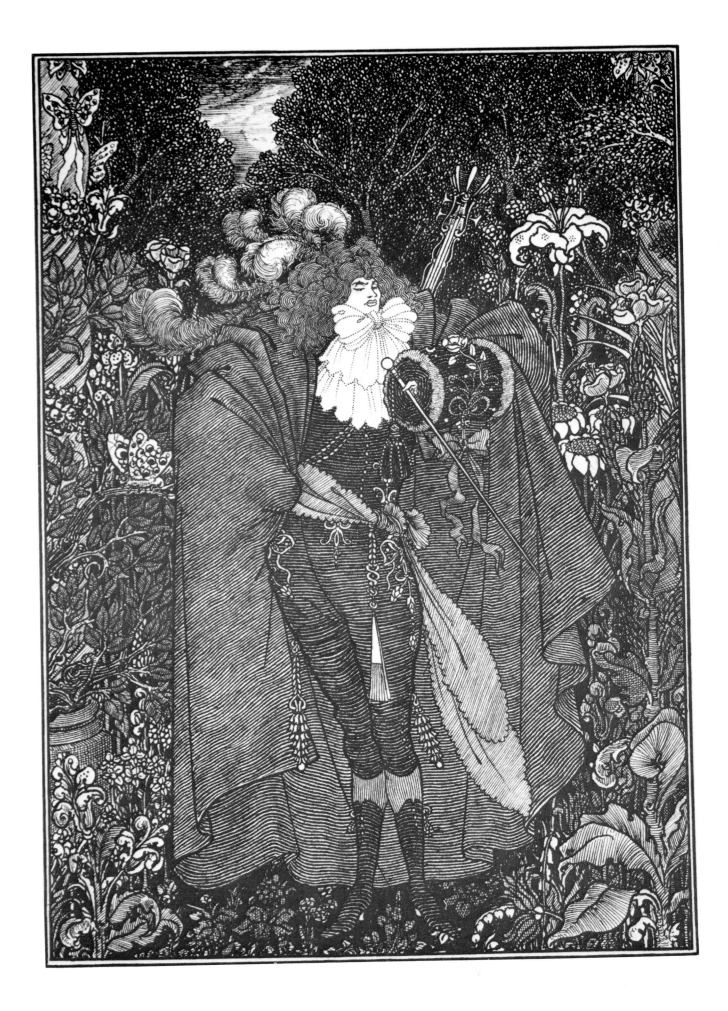

The Toilet

ILLUSTRATION TO *THE RAPE OF THE LOCK* BY ALEXANDER POPE. INK DRAWING, 25.5 × 17.5 CM. 1896. CLEVELAND MUSEUM OF ART

Alexander Pope wrote *The Rape of the Lock* in 1712 after an incident in which Lord Petre cut off a lock of the hair of a Mrs Arabella Fermor and caused a quarrel between their families. Pope created a satirical masterpiece by treating the incident at length in the full heavyweight classical poetic manner of the early eighteenth century. The poem is dedicated by the author to Arabella Fermor who in the poem becomes Belinda. Both the lightheartedness and the classical feel of Pope's poem are reflected in Beardsley's illustrations which are among the most restrained major drawings he ever made. For this reason perhaps they have often been his most admired works.

Beardsley has here indulged his fascination with dressing-table scenes (*see also* Plate 14) and pictured Belinda's toilet at the start of the poem. Pope introduces Belinda thus:

> This nymph, to the Destruction of Mankind
> Nourish'd two locks which graceful hung behind
> In equal curls, and well conspir'd to deck
> With shining Ringlets the smooth Iv'ry Neck.
> Love in these Labyrinths his Slaves detains
> And mighty Hearts are held in slender Chains.

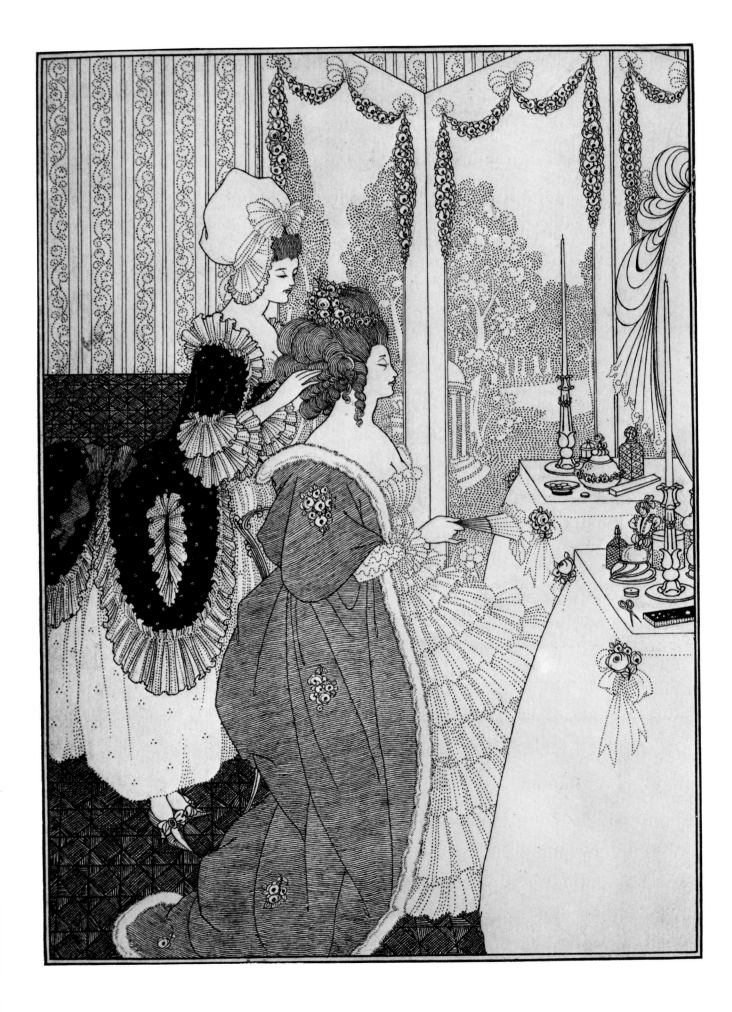

The Baron's Prayer

ILLUSTRATION TO *THE RAPE OF THE LOCK* BY ALEXANDER POPE. INK DRAWING, 25.5 × 17 CM. 1896. CAMBRIDGE (MASS.), FOGG ART MUSEUM

Perhaps the most captivating of Beardsley's illustrations to *The Rape of the Lock*. It shows the Baron, who has been fascinated by Belinda's locks, praying at a makeshift Altar to Love built of French erotic novels and bits of his previous mistresses' underwear, on which he lights a sacrificial fire of old love letters:

> Th' Advent'rous *Baron* the bright Locks admir'd
> He saw, he wish'd, and to the Prize aspir'd: ...
> For this, ere *Phoebus* rose, he had implor'd
> Propitious Heav'n, and ev'ry Pow'r ador'd,
> But chiefly *Love* – to *Love* an Altar built,
> Of twelve vast *French* Romances, neatly gilt.
> There lay three Garters, half a Pair of Gloves,
> And all the Trophies of his former Loves.
> With tender *Billet-doux* he lights the Pyre
> And breathes three am'rous Sighs to raise the Fire.

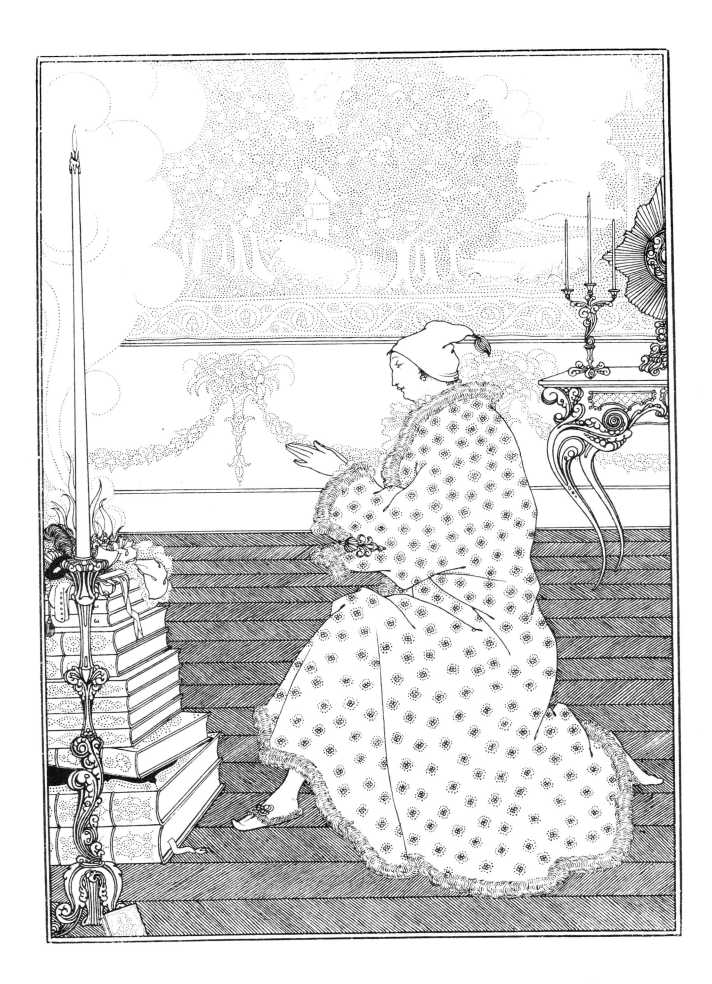

The Cave of Spleen

ILLUSTRATION TO *THE RAPE OF THE LOCK* BY ALEXANDER POPE. INK DRAWING, 25 × 17.5 CM. 1896. BOSTON, MUSEUM OF FINE ARTS

The Baron's prayer is granted and he is enabled to snip off one of Belinda's locks while she is distracted by fashionable coffee drinking. She naturally falls into a rage, which gives Pope the opportunity for a long fanciful account of the domain of the goddess of Spleen, or ill temper, where '*Umbriel,* a dusky, melancholy Sprite' goes to seek further fuel for Belinda's anger. This passage is the most fantastic and grotesque in the poem and evidently appealed to Beardsley who produced this bizarre composition, crowded with the creatures described by Pope. In the right centre is the Goddess herself: '... screen'd in Shades from Day's detested Glare,/She sighs forever on her pensive Bed ...' Beside her is '*Ill-nature* like an *ancient Maid,*/Her wrinkled form in *Black and White* array'd.' As for the rest: 'Strange Phantoms rising as the Mists arise; ... Unnumber'd Throngs, on ev'ry Side are seen,/Of Bodies chang'd to various forms by *Spleen.*/Here living *Teapots* stand, one Arm held out ...' The living teapots can be seen in the left foreground of the drawing, two of them pregnant with visible embryos: 'Men prove with child, as pow'rful Fancy works.' The other principal figure is the messenger Umbriel addressing the Goddess: 'Hear me, and touch *Belinda* with Chagrin.' She duly gives him 'A wond'rous Bag' which contains '... the force of Female Lungs,/Sighs, Sobs and Passions, and the War of Tongues ...' Armed with this, Umbriel returns to Belinda. As Robert Halsband has pointed out in his pioneering analysis of Beardsley's drawings for *The Rape of the Lock**, the artist has inserted into *The Cave of Spleen* a portrait of Pope himself — it is the figure in spotted robe and cap looking out from the very centre of the composition.

*In *The Rape of the Lock and its Illustrations 1714–1896,* Clarendon Press, 1980.

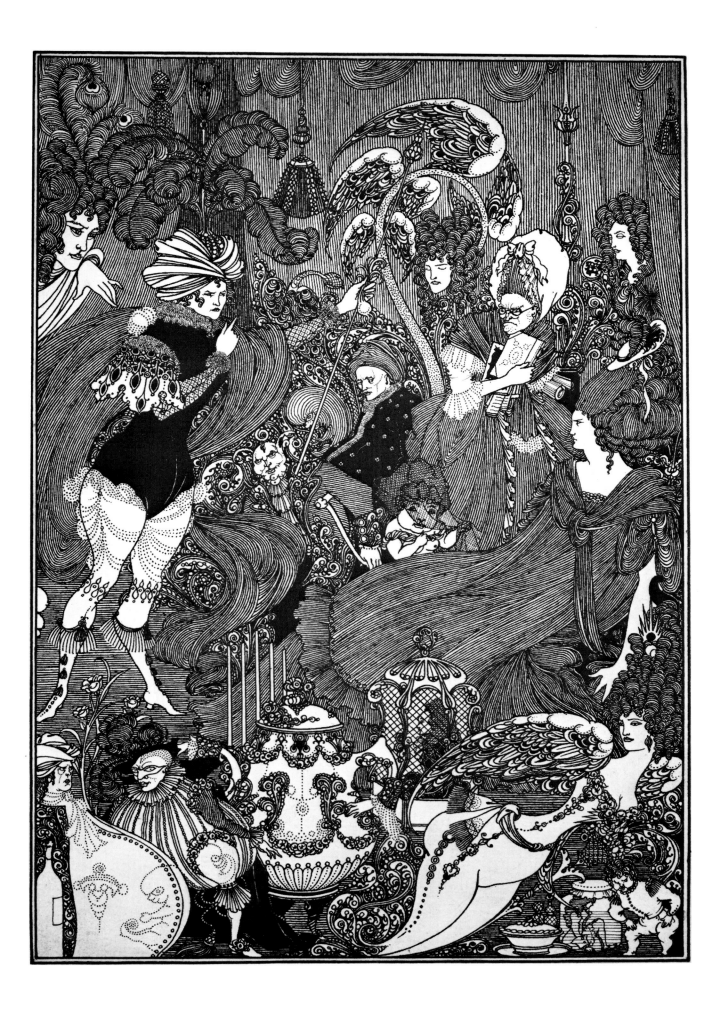

The Battle of the Beaux and the Belles

ILLUSTRATION TO *THE RAPE OF THE LOCK* BY ALEXANDER POPE. INK DRAWING, 25 × 17 CM. 1896. BIRMINGHAM, THE BARBER INSTITUTE OF FINE ARTS

This drawing is an incomparable image of a beautiful woman in a rage with a man. Duly encouraged by the gift from the Goddess of Spleen, Belinda eventually confronts the Baron and demands the return of her hair. He refuses. Belinda resorts to force, and defeats the Baron by throwing snuff in his face:

> See fierce *Belinda* on the *Baron* flies,
> With more than usual Lightening in her Eyes:
> Nor fear'd the Chief th' unequal Fight to try,
> Who sought no more than on his Foe to die.
> But this bold Lord, with manly Strength endu'd
> She with one Finger and a Thumb subdu'd:
> Just where the Breath of Life his Nostrils drew,
> A charge of *Snuff* the wily Virgin threw ...

Beardsley shows the Baron, defeated, kneeling before Belinda, prepared, in mock heroic manner, to die except:

> All that I dread, is leaving you behind!
> Rather than so, ah let me still survive,
> And burn in *Cupid's* Flames — but burn alive.

The Battle of the Beaux and the Belles is another of those drawings which must be numbered among Beardsley's most perfect masterpieces. Absolutely classical in composition, it is balanced, harmonious, monumental, yet vividly expressive of the emotions of the two protagonists. The fallen chair, completely natural in the circumstances, is a brilliant compositional device for blocking the foreground and creating a sense of real space for the figures behind. Among individual details the drawing of the Baron's brocade coat is breathtaking.

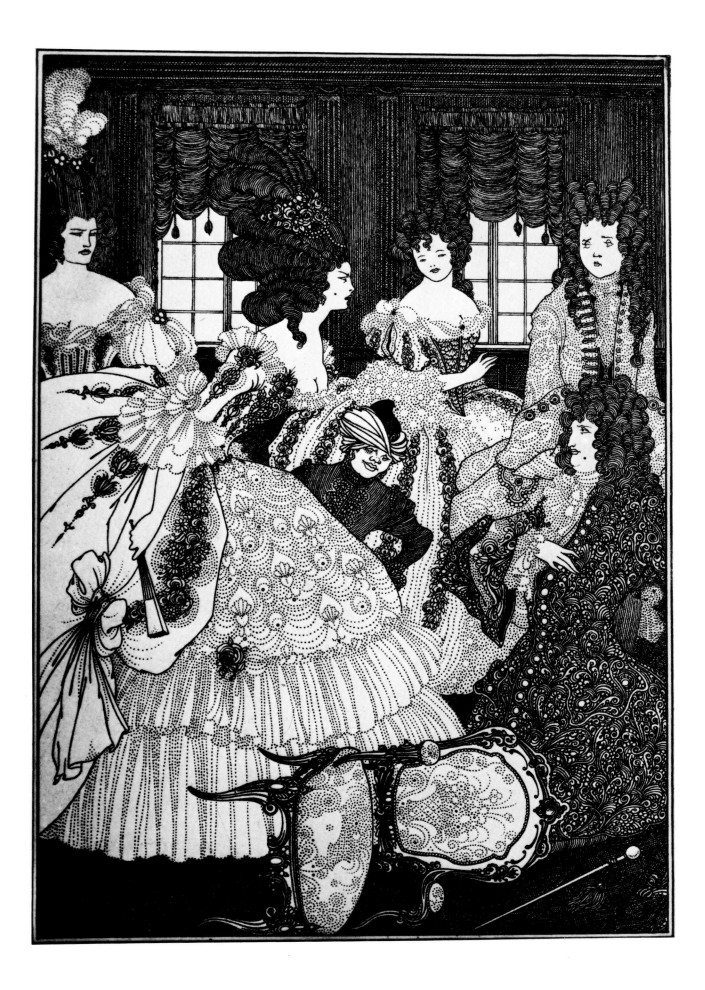

Cover of *Volpone* by Ben Jonson

GOLD STAMPED ON VELLUM, 29 × 22 CM. 1898. LONDON, COURTESY OF ROBERT M. BOOTH

Cover of *A Book of Fifty Drawings*

GOLD STAMPED ON VELLUM, 28.5 × 22 CM. 1897. LONDON, COURTESY OF ROBERT M. BOOTH

By the late 1890s publishers had got into the habit of producing sumptuous 'large paper' editions of their books, usually distinguished from the ordinary edition not only by a slightly larger size but by better quality paper, often, as here, so-called japanese vellum, and by the use of real vellum instead of cloth for the binding. Large paper editions were produced in small numbers: this copy of *Volpone* is numbered 91 of 100 copies, the *Book of Fifty Drawings* is 36 of 50. Both were produced by Leonard Smithers. Beardsley made the cover design used for *Volpone* in November 1897 at the Hotel Foyot in Paris. It was originally intended for *Ali Baba* (Plate 46) but in his desperation to complete *Volpone* in the last months of his life Beardsley transferred it. In the end he only completed a frontispiece (Plate 48) and five initial letters for Volpone, and the book was not published until after his death.

A Book of Fifty Drawings, referred to by Beardsley as his 'album', was the first published collection of Beardsley's work and included an 'iconography' or list of works by Aymer Vallance. The beautiful cover design was done about September 1896 and the book appeared early in 1897. In a letter to Smithers postmarked 14 January 1897 Beardsley wrote, 'The large-paper copy of the Album is in every way worthy of its price (2 guineas) and better than the small edition a thousand times … Please accept my thanks. The cover looks sumptuous.'

The Third Tableau of *Das Rheingold*

INK DRAWING, 25.5 × 17.5 CM. 1896. RHODE ISLAND SCHOOL OF DESIGN, MUSEUM OF ART

The drawings for the Third and Fourth tableaux of Wagner's *Das Rheingold* form part of a group of illustrations for this opera that Beardsley planned, but never completed.

In *The Third Tableau* Wotan, king of the gods, and Loge, the wily god of Fire, are in the underworld of the Nibelungen, the Rheindwarfs, attempting to recover the gold stolen by the dwarf Alberich. The power of the gold, part of it now forged into a ring, has enabled Alberich to enslave his people and to obtain a magic helmet. As a first step towards obtaining the ring, Loge taunts Alberich into demonstrating the helmet which he does by turning himself into a dragon, at which Loge makes a great pretence of fear.

In *The Fourth Tableau* (Fig. 29) Loge and Wotan have triumphed over Alberich and forced him to return the gold to them on the misty mountain heights where the gods dwell. Beardsley pictures them there, Loge pointing triumphantly down at the treasure.

In both pictures Beardsley appropriately draws the Flame god's robes as a system of flame-like forms. These forms are quite extraordinary visual inventions in themselves; indeed, as Brian Reade has remarked, they are without precedent in European art, and become even more so when considered as pictorial equivalents to the flickering flame motif which accompanies Loge in the score of the opera.

The Third Tableau of Das Rheingold was published as an illustration to the second part of *Under The Hill* (Plate 28) in *The Savoy* No. 2, April 1896. *Das Rheingold* appears in *Under The Hill* as one of the Abbé Fanfreluche's bedside books and there is a long appreciative description of it, particularly of the Third Tableau, which clearly appealed strongly to Beardsley: '... Alberich's savage activity and metamorphoses, and Loge's rapid, flaming tongue-like movements make the tableau the least reposeful, most troubled and confusing thing in the whole range of opera. How the Abbé rejoiced in the extravagant

Fig. 29
The Fourth Tableau of *Das Rheingold*

INK DRAWING, 31 × 22 CM. 1896. LONDON, THE VICTORIA AND ALBERT MUSEUM

monstrous poetry, the heated melodrama and splendid agitation of it all!'

The Fourth Tableau was drawn as the front cover design for *The Savoy* No. 6.

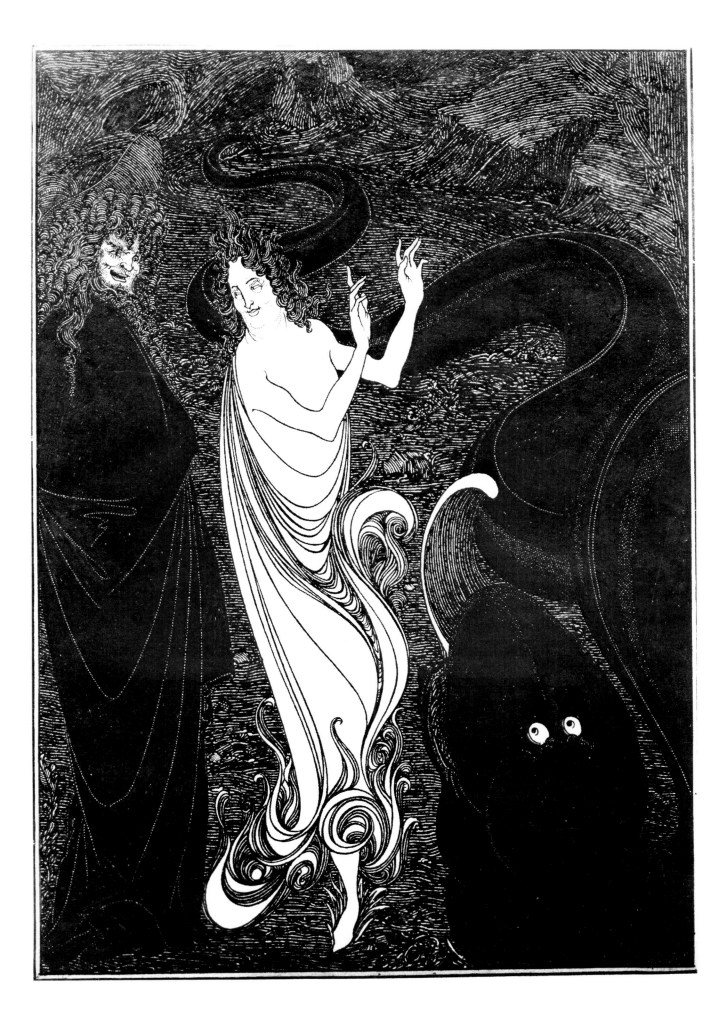

The Toilet of Lampito

ILLUSTRATION TO THE *LYSISTRATA* OF ARISTOPHANES. INK DRAWING, 25 × 17 CM. 1896. LONDON, THE VICTORIA AND ALBERT MUSEUM

Aristophanes (*c*.445–386 BC) was the most celebrated comic poet of ancient Athens. *Lysistrata* was written and first performed in Athens in 411 BC at the height of the disastrously destructive internecine wars between the city states of Athens and Sparta (also known as Lacedaemon). The theme of the play is the attempt by the Athenian and Spartan women, led by the remarkably modern Lysistrata, to end the war by withholding sexual favours from their men until they agree to stop fighting. Aristophanes obtains a great deal of very bawdy and extremely funny mileage out of this, but the play's underlying message of the waste and futility of war is deeply serious and remains, 2000-odd years later, as sadly relevant as ever.

Beardsley's illustrations reflect the bawdiness of the play but they are drawn in a style of great purity, a highly refined development of the open linear manner of the *Salome* drawings. The figures are rendered solely in outline, yet have an astonishing feeling of completeness and solidity. They are placed on completely blank grounds yet appear convincingly to be standing in a naturalistic space. These drawings are a *tour de force* and although they lack the startling originality of the *Salome* series show, as do the *Rape of the Lock* drawings, how Beardsley's sheer genius as a draughtsman continued to mature and intensify as he grew older.

Lampito is one of the Spartan women summoned to the meeting in Athens at which Lysistrata announces her sexual strike plan. The scene Beardsley has depicted does not occur in the play but is an erotic fantasy probably stimulated by Lysistrata's enthusiastic greeting of Lampito, with its implication that she has made careful preparation before venturing out: 'Good morning my dearest Spartan Lampito. How brilliant your beauty is, you delicious creature! What a lovely colour you have, and how plump and full your body is.'

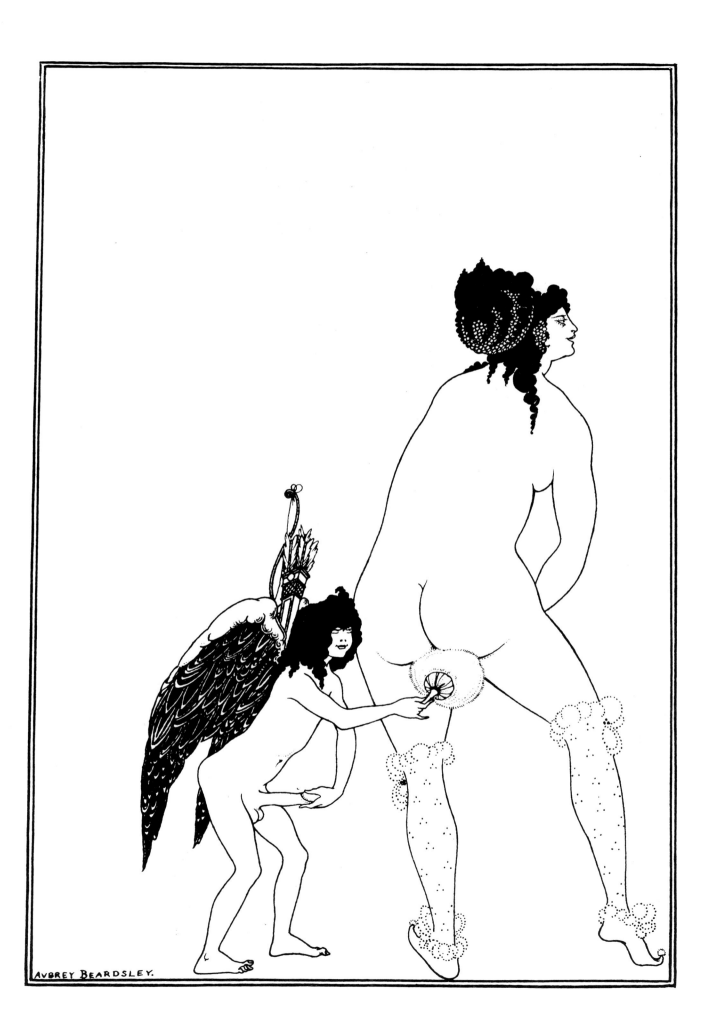

Two Athenian Women in Distress

ILLUSTRATION TO THE *LYSISTRATA* OF ARISTOPHANES. COLLOTYPE REPRODUCTION, 23.5 × 16 CM. 1896 LONDON, THE VICTORIA AND ALBERT MUSEUM

After deciding on their strike Lysistrata and the women occupy the Acropolis and announce that they will refuse to come out until the men come to terms. Unfortunately, sexual abstention quickly takes its toll on the women and Lysistrata finds her troops deserting her: 'I cannot keep them away from their husbands: they are running off. I found the first one picking open the hole where the cave of Pan is; another one slipping down by the pulley; another I caught in the very act of deserting; and another one I dragged off a sparrow by the hair yesterday...'

Beardsley has drawn the woman descending on the rope and pulley and has rendered quite literally the image of the one escaping on the back of a sparrow with Lysistrata's arm reaching for her hair from outside the top edge of the drawing — a startling piece of composition.

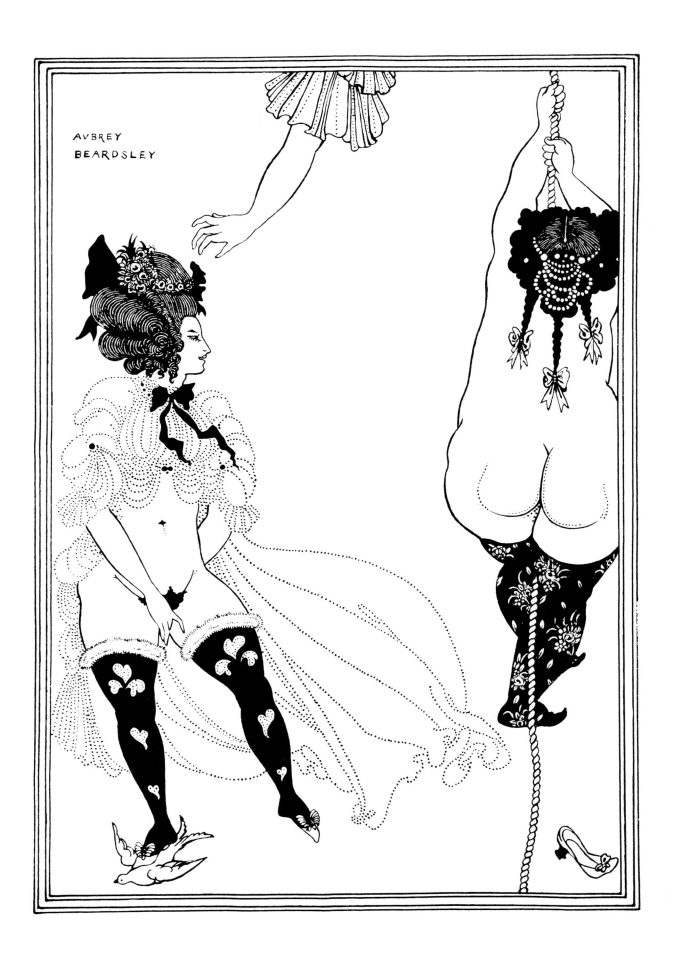

Cinesias Entreating Myrrhina to Coition

ILLUSTRATION TO THE *LYSISTRATA* OF ARISTOPHANES, INK DRAWING, 26 × 18 CM. 1896. LONDON, THE VICTORIA AND ALBERT MUSEUM

Cinesias, husband of Myrrhina, returns from the fighting in an extremely deprived state: as Lysistrata puts it, 'writhing in Aphrodite's love-grip.' She instructs Myrrhina to tease him until he is in such a state that he will agree to anything, even peace with Sparta. The result is one of the most brilliantly sustained and brilliantly comic scenes in the history of the theatre, ending with Cinesias completely bewildered and still unsatisfied. Beardsley has accurately pictured his condition as he fruitlessly pursues his wife about the stage.

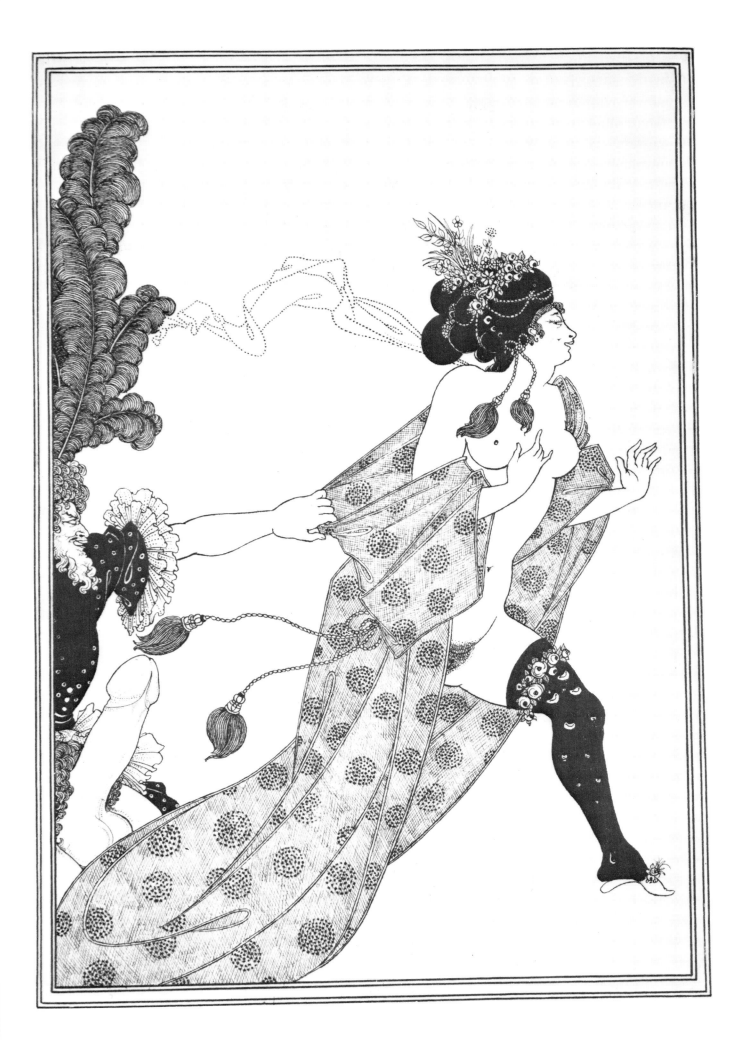

The Lacedaemonian Ambassadors

ILLUSTRATION TO THE *LYSISTRATA* OF ARISTOPHANES. INK DRAWING, 26 × 18 CM. 1896. LONDON, THE VICTORIA AND ALBERT MUSEUM

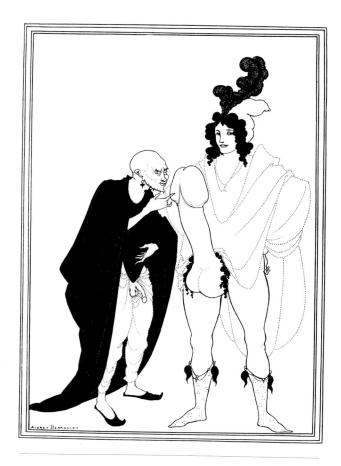

The condition of Cinesias (Plate 37) was the first indication of the impact of the strike of the Athenian and Spartan women. The full extent of their success is quickly made apparent by the arrival of a herald from Sparta followed by a group of ambassadors come to sue for peace. They are all in the same painful condition. The herald is examined with some incredulity by one of the Athenian committee of old men who have been attempting to resist Lysistrata:

COMMITTEE MAN: Is that a spear you've got tucked under your arm?

HERALD: No by Jove, it isn't.

COMMITTEE MAN: Why do you turn round? Why does your cloak protrude like that? ... How do you account for this affliction! Is it from Pan?

HERALD: No. Lampito was the origin of it, and then all the women of Sparta, as if with one accord, repulsed their husbands from their coyntes.

When the ambassadors arrive in Athens they are greeted by the old men:

CHORUS OF OLD MEN: Spartans, in the first place, welcome! Next, tell us in what plight you come!

AMBASSADOR: Why waste many words? You can see in what plight we come.

Lysistrata then makes a speech of masterly diplomacy and brings the Athenians and Spartans to terms.

Fig. 30
The Examination of the Herald

ILLUSTRATION TO THE LYSISTRATA OF ARISTOPHANES. INK DRAWING, 26 × 18 CM. 1896. LONDON, THE VICTORIA AND ALBERT MUSEUM

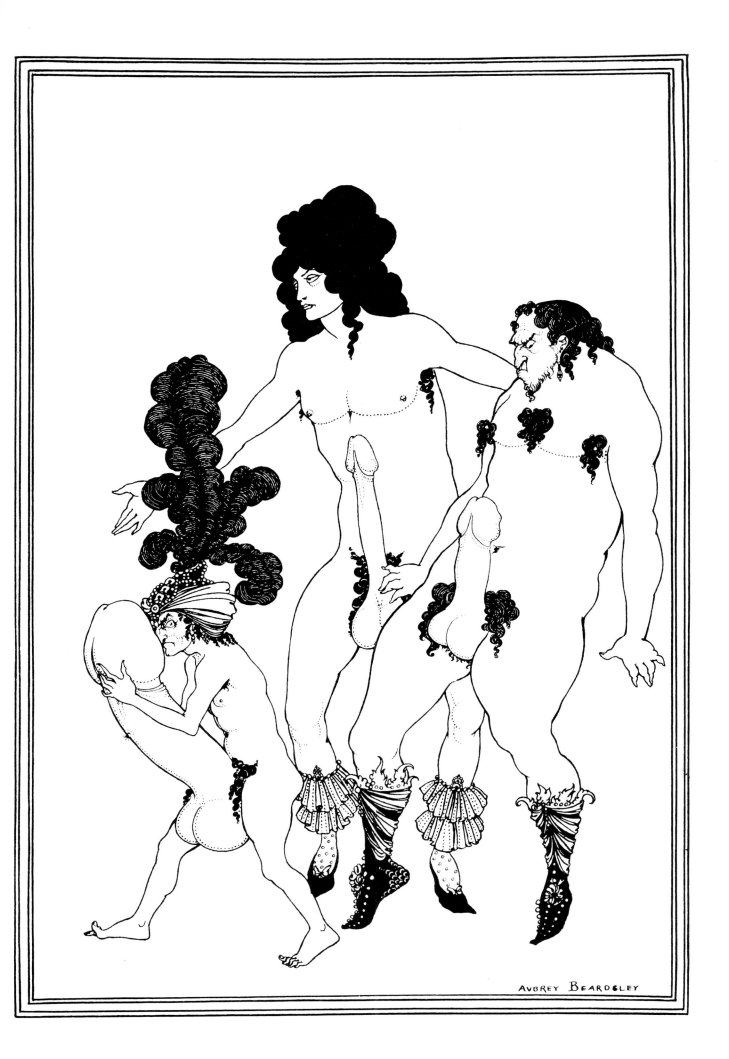

Isolde

COLOUR LITHOGRAPH, 23 × 14.5 CM. 1895. FROM THE STUDIO MAGAZINE

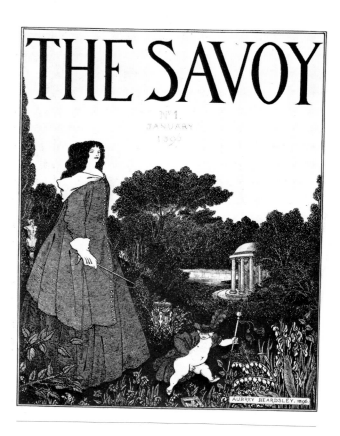

Fig. 31
Cover Design for *The Savoy* No. 1

INK DRAWING, 30.5 × 23 CM. 1896. CAMBRIDGE (MASS.), FOGG ART
MUSEUM

The original drawing for Isolde in grey washes is now in the Fogg Art Museum. It was reproduced in the strong colours seen here as a colour lithograph supplement to *The Studio* in October 1895, an experiment which paid off, the very simple, bold colour scheme well complementing the boldness and economy of Beardsley's design. Although there is no evidence it seems certain that Beardsley would have decided the colours to be used, which are basically the same as he chose for those few of his original drawings to which he added colour. The subject is another from his favourite Wagner opera *Tristan und Isolde*, showing Isolde about to drink the love drink. A full account of this scene is given in the notes to Plate 5. Beardsley shows Isolde on stage in front of a curtain and in the dress of his own period, possibly to stress the timelessness of the great romantic themes of art.

Fig. 31 is the original drawing for the front cover of *The Savoy*, No. 1. The putto in the foreground is about to urinate on a copy of what can just be seen to be a copy of *The Yellow Book*, a neat expression of Beardsley's feelings about his sacking from it. However, the prominent novelist and art critic George Moore apparently considered this detail to be a needless provocation and his influence got it removed from the published cover. The drawing is a beautiful example of Beardsley's pastoral mode, like the unused cover for *The Yellow Book* Volume Five (Fig. 27). It reveals the influence on Beardsley at this time of the great seventeenth-century landscape painter Claude Lorrain, whose work Beardsley greatly admired.

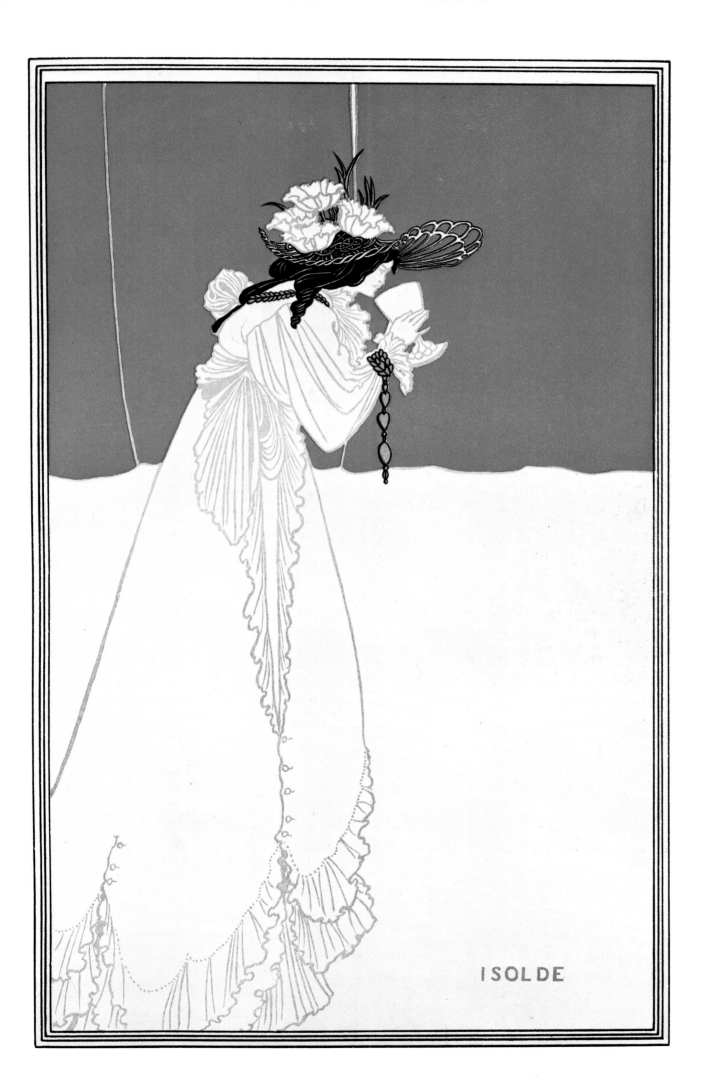

ISOLDE

Messalina Returning Home

ILLUSTRATION TO THE SIXTH SATIRE OF JUVENAL. INK DRAWING, 17.5 × 14.5 CM. 1896. LONDON, THE VICTORIA AND ALBERT MUSEUM

Beardsley made five drawings illustrating the Sixth Satire by the Roman poet Juvenal (*c.*AD 55–138), a savage denunciation of the morals of upper-class Roman women of his period. Messalina was the utterly depraved, murderous wife of the Emperor Claudius (10 BC – AD 54). Juvenal describes her habit of leaving the Imperial Palace at night to become a whore in a brothel under the name of Lycisca, the Wolf-girl: 'A more than willing partner, she took on all comers, for cash, without a break./Too soon, for her, the brothel keeper dismissed/His girls. She stayed till the end always the last to go/Then trailed away sadly .../Retiring exhausted, yet still far from satisfied, cheeks begrimed with lamp-smoke, filthy, carrying home/To her imperial couch the stink of the whorehouse.' (Translation Penguin Classics, 1967). Beardsley's drawing depicts her dishevelled return, her fist clenched in continuing frustration.

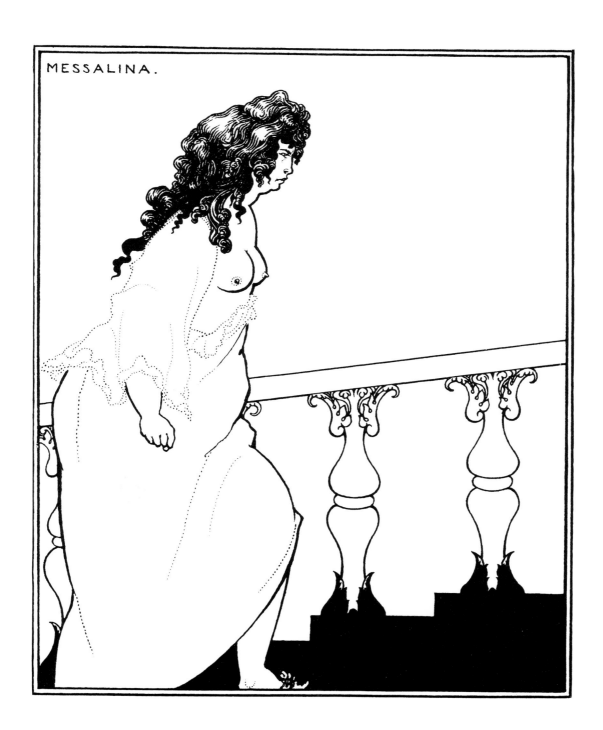

Messalina

INK DRAWING WITH ADDED WATERCOLOUR, 28 × 18 CM. 1895, LONDON, THE TATE GALLERY

The other of the two drawings of Messalina Beardsley made (*see* Plate 40). In style it clearly relates to the night pieces of the *Yellow Book* period and indeed the suggestion is much more of the streets of London in Beardsley's time than of ancient Rome. However, in every other way this image closely corresponds to part of Juvenal's description of Messalina in his *Sixth Satire*: '... that whore-empress — who dared to prefer the mattress/Of a stews to her couch in the Palace, called for her hooded/Night-cloak and hastened forth, alone or with a single/Maid to attend her. Then, her black hair hidden/Under an ash-blonde wig, she would make straight for her brothel...'

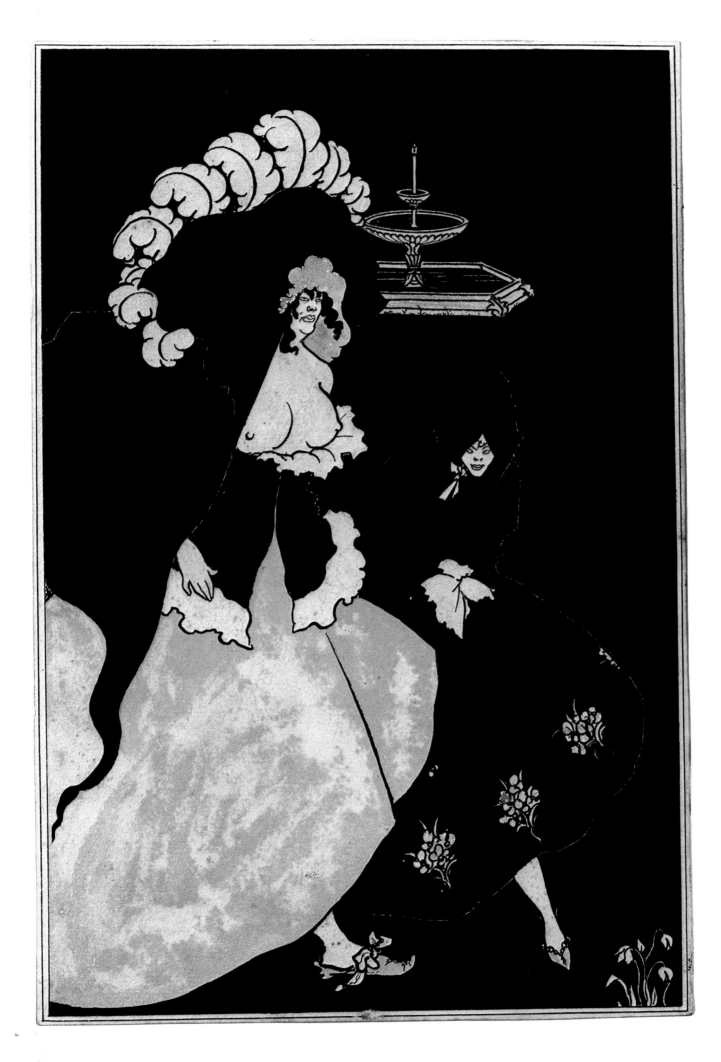

The Impatient Adulterer

ILLUSTRATION OF THE *SIXTH SATIRE* OF JUVENAL. INK DRAWING, 18 × 10 CM. 1896-7. LONDON, THE VICTORIA AND ALBERT MUSEUM

Beardsley sold this drawing to his young friend Herbert Pollit who beside Leonard Smithers and André Raffalovitch was another, less important, patron of Beardsley's last years. Beardsley wrote to him in March 1897: 'The little drawing for Juvenal VI 237–8 is done.

> Abditus interae latet et secretus adulter,
> Impatiensque morae pavet et praeputia ducit.
> It looks very well; shall I confide it to the post?'

These lines occur in a passage in Juvenal's *Sixth Satire* in which Juvenal advises a friend contemplating marriage of the adulterous habits of Roman matrons and particularly the way they aid and abet their daughters in adultery, pretending to be ill in order to give the daughter an excuse to visit the mother's house and meet her lover there: 'She eggs her daughter on ... She gives advice/On the subtlest least obvious way to answer billets-doux/From would be seducers. Its she who hoodwinks or fixes your servants, she who takes to her bed when she's well/Who lies tossing and turning under the sheets till the doctor/Makes his visit. Meanwhile all hot impatience,/Hidden behind the scenes, her daughter's lover keeps mum and pulls his wire.' (Translation Penguin Classics, 1967.) The last two lines are those quoted in Latin by Beardsley.

Pollit evidently appreciated the drawing, for not long after selling it to him in March 1897 Beardsley wrote to him: 'You are quite right, the Juvenal drawing is admirable. I long to hear of your having acquired some superb quarto into which it can be bound.'

A particularly nice touch in *The Impatient Adulterer* is the way Beardsley has rendered his toes twisting convulsively together in an agony of impatience.

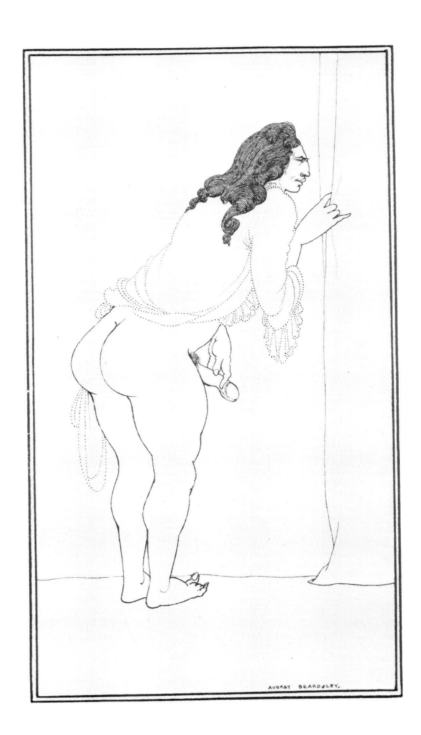

Covers of two volumes of the Keynotes series

LINE BLOCK PRINTED ON CLOTH, EACH 20 × 12 CM. BOTH PUBLISHED 1894. PRIVATE COLLECTION

For details of the *Keynotes* series of novels and short stories see note to Plate 23. Beardsley's masterly design for *Poor Folk* presumably represents Varvara, the female protagonist of Dostoevsky's novel in letters of the hopeless love of an old clerk for his young cousin. Beardsley has done his best to introduce a note of gritty realism with the drainpipe but has succeeded instead in creating the most elegant piece of plumbing in the history of art.

Forence Farr, authoress of *The Dancing Faun*, was the actress and writer for whom Beardsley made the poster reproduced at Plate 17. The title evidently gave him the idea of drawing a faun which he turned into a caricature of Whistler. The drawing for this cover, the caricature of Whistler's wife (Plate 21) and the *Caricature of Whistler on a Garden Seat* (Fig. 32) were all made in late 1893 or

early 1894. At this time Beardsley seems to have been taking every opportunity of avenging Whistler's snubbing of him in Paris in 1893. According to one of his letters to André Raffalovitch, Beardsley hung the drawing of *Whistler on a Garden Seat* on his Christmas tree in 1894 '...Mabel and I had such a lovely Christmas tree, hung with such pretty things. I recollect some volumes of Verlaine and a very malicious caricature of Whistler by myself were upon the branches.'

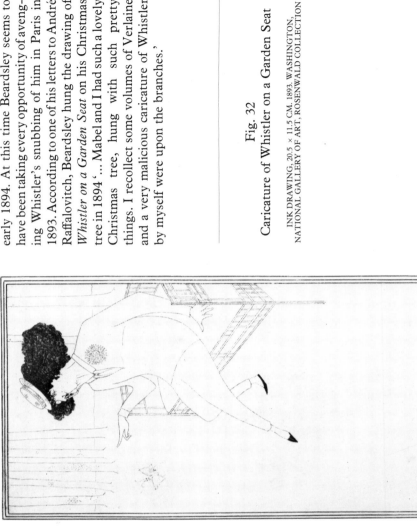

Fig. 32
Caricature of Whistler on a Garden Seat

INK DRAWING, 20.5 × 11.5 CM. 1893. WASHINGTON, NATIONAL GALLERY OF ART, ROSENWALD COLLECTION

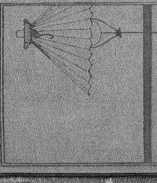
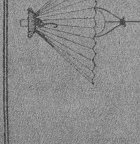

The Lady with the Monkey

ILLUSTRATION TO *MADEMOISELLE DE MAUPIN* BY THEOPHILE GAUTIER. INK DRAWING, 20 × 17 CM. 1897. LONDON, THE VICTORIA AND ALBERT MUSEUM

The project to illustrate Gautier's *Mademoiselle de Maupin* is one of those started by Beardsley in the last year of his life and, sadly, never completed. In August 1897 he wrote to Herbert Pollit: 'Mlle de Maupin is the book and is to be printed in French and eight monthly parts! You may offer up any number of prayers for the completion of the pictures.'

Mademoiselle de Maupin was written by Gautier at the age of 24 and was first published in 1835. As its most recent translator (Joanna Richardson, Penguin Classics, 1981) into English says '... no novel better embodies the careless rapture of the young Romantic.' It is a hymn to erotic love and to the love of visual beauty as cardinal elements in life. It is the source of the doctrine of 'art for art's sake' and became a key text for the whole of the later Romantic and Decadent movement.

At the core of the book is the story of a triangular love affair between D'Albert, the young poet hero, his delicious mistress Rosette and the outrageously handsome Théodore who in reality is a woman, Mademoiselle de Maupin. Both Rosette and D'Albert fall passionately in love with Théodore/Maupin, D'Albert with some bewilderment since although he suspects and fervently wishes Théodore to be a woman, he is far from sure and is somewhat worried at finding himself in love with what might very well be a man! This is the background to the scene which is the subject of the drawing, one of his last great masterpieces, that Beardsley called *The Lady with the Monkey*. D'Albert, Rosette and Théodore decide to amuse themselves with an amateur production of Shakespeare's *As You like It* in which the character of Rosalind, except for the first act, spends most of the play disguised as a man. It is decided that Théodore/Maupin will play Rosalind and dress as a woman for the first act appearance. The result is that Maupin appears for the first time as the beautiful woman she really is, to the relief and ecstasy of D'Albert and the devastation of Rosette.

Beardsley has marvellously captured the moment of Maupin's entry into the room as she pauses, eyelids modestly lowered, in the light of a window: 'A sharp ray of light illumined her from head to foot ... she sparkled as if the light were emanating from her instead of simply being reflected and you would have taken her for a wonderful creation of the brush rather than a human being made of flesh and blood.

'Her long brown hair, intertwined with strings of big pearls, fell in natural curls down her lovely cheeks; her shoulders and her bosom were bare, and I have never seen anything in the world that was so beautiful.' (Penguin Classics, 1981.)

Beardsley has not precisely followed Gautier's detailed description of Maupin except in the essentials of her bare bosom and, above all, the beauty of her face, one of the great examples in art of imagined female beauty and remarkable particularly for its delicate but powerful sensuality. The monkey on the window-ledge acting as Maupin's master of ceremonies is Beardsley's own invention.

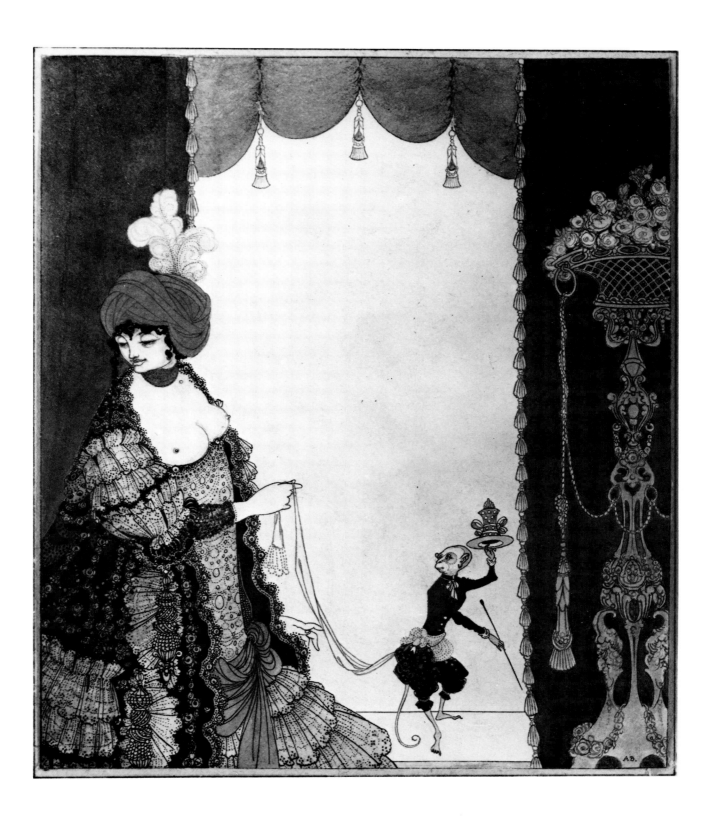

Cover of *The Houses of Sin* by Vincent O'Sullivan

GOLD STAMPED ON PARCHMENT BOARD, 23 × 14.5 CM. PRIVATE COLLECTION

Cover of *Verses* by Ernest Dowson

GOLD STAMPED ON PARCHMENT BOARD, 20 × 15.5 CM. 1896. LONDON, COURTESY OF ROBERT M. BOOTH

Vincent O'Sullivan was an American born writer whom Beardsley came to know well in 1896, designing a frontispiece for his *Book of Bargains* as well as the cover of *The Houses of Sin*, a collection of Decadent poems. Beardsley thought that *The Houses of Sin* was 'Quite O'Sullivan's best book' and it inspired him to produce one of the most sumptuous and appropriate of all his book cover designs. The extraordinary flying pig's head, beautiful but grotesque, is Beardsley's version of the traditional representation of the breeze as a winged head with puffed cheeks. It also very convincingly represents the idea of sin in the person of an elaborately farded and coiffed piggy-faced old harlot. The great baroque pillar which the breeze is, so to speak, caressing, is part of the portal of one of the 'Houses of Sin' described in the title poem of the collection, in which also occurs the image of the breeze as seducer: 'Then, as a perfumed wind came glancing by/And kissed me with its melancholy sigh,/And wooed me to its lair/Of flower haunted rooms ...'

The Houses of Sin is a particularly satisfying book to handle partly because of its unusual narrow upright format and partly because the design was repeated on the back cover. This was apparently on the insistence of Wilde who, great connoisseur of beautiful books that he was, proved absolutely right. Beardsley also had his own ideas about this cover: 'I am sending tomorrow the cover for O'Sullivan's book,' he wrote to Smithers. 'It is to be printed in gold upon black smooth cloth. No other way. Purple however might be an alternative to print upon.' Interesting though they are it is difficult to imagine either of these alternatives being more effective than the final choice of gold on cream.

The cover of Dowson's *Verses* has always been greatly admired as a masterpiece of art nouveau design at its most elegantly simple. The book itself is one of the most characteristic collections of Decadent poetry of the 1890s. It contains two poems in particular which are summations of important aspects of the Decadent spirit. One, *Non Sum Qualis Eram Bonae Sub Regno Cynarae (I am not what I was under the rule of good Cynara)* is the poem that ends each of its four stanzas with the celebrated line: 'I have been faithful to thee, Cynara! in my fashion.'

The other is worth quoting in full:

They are not long, the weeping and the laughter,
Love and desire and hate:
I think they have no portion in us after
We pass the gate
They are not long, the days of wine and roses:
Out of a misty dream
Our path emerges for a while, then closes
Within a dream.

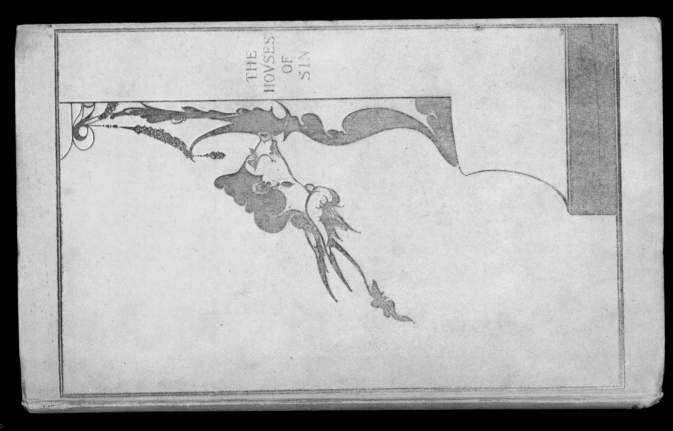

THE
HOVSES
OF
SIN

Ali Baba in the Wood

INK DRAWING, 23.5 × 17.5 CM. 1896. CAMBRIDGE (MASS.), FOGG ART MUSEUM

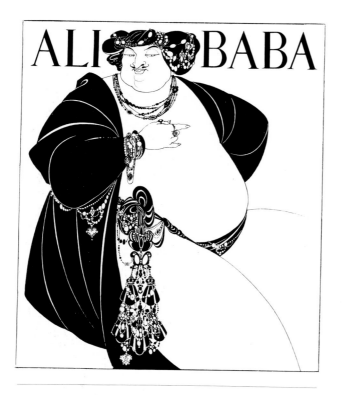

Smithers proposed to Beardsley that he should illustrate the story of *Ali Baba and the Forty Thieves* in July 1896. The first drawing *Ali Baba in the Wood* was completed by late July 1896 but the second, a design for the cover of the book, was not made until nearly a year later, in May 1897. No more were done and the book was never published. At the beginning of the story Ali Baba is a poor wood-cutter. One day in the forest he observes a band of robbers arriving at their secret hideaway, a cave whose door opens at the command 'open sesame'. The drawing depicts the moment when Ali Baba comes out of hiding after seeing the robbers depart. The figure of Ali Baba is one of Beardsley's most brilliant pieces of characterisation in which Ali's intense nervous apprehension is vividly rendered through the acutely realised expression of his face and the extraordinarily eloquent drawing of the hands.

The cover design shows Ali Baba as he becomes after plundering the robbers' treasure house. It is a magnificent image, a great example of Beardsley's ability to create luxurious effects from the austere deployment of simple black and white.

Fig. 33
Ali Baba

INK DRAWING, 24 × 20 CM. 1897. CAMBRIDGE (MASS.), FOGG ART MUSEUM

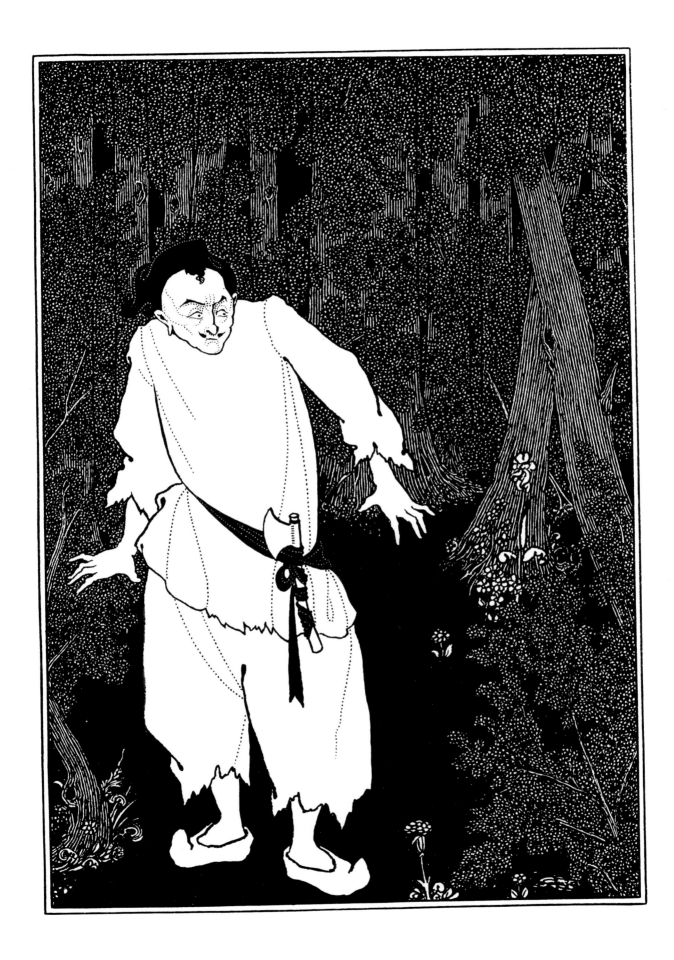

Cover of *The Rape of the Lock* Large Paper Edition

GOLD STAMPED ON VELLUM, 26 × 20 CM. 1896. No. 1 of 25 COPIES.
LONDON, COURTESY OF ROBERT M. BOOTH.

Cover of *The Rape of the Lock* Ordinary Edition

GOLD STAMPED ON BLUE CLOTH 26 × 19.5 CM. 1896. EDITION SIZE UNKNOWN.
LONDON, COURTESY OF ROBERT M. BOOTH

Cover of *The Rape of the Lock* Bijou Edition. Large Paper

GOLD STAMPED ON VELLUM, 15 × 12 CM. 1897. No. 30 of 50 COPIES.
LONDON, COURTESY OF ROBERT M. BOOTH

Cover of *The Rape of the Lock* Bijou Edition

GOLD STAMPED ON RED CLOTH, 14.5 × 11 CM. 1897. No. 1 of 1000 COPIES.
LONDON, COURTESY OF ROBERT M. BOOTH

The various editions of *The Rape of the Lock* that Smithers saw fit to produce give a good idea of the size of the market for beautiful and expensive editions in the 1890s. The cover is a marvellous combination of rococo exuberance and restrained elegance, and like Beardsley's illustrations (Plates 29–32) entirely in keeping with the spirit of the book. Beardsley's very beautiful drawing illustrating Swinburne's long dramatic poem

Atalanta in Calydon was intended for publication in the ill-fated *Yellow Book* Volume Five. The drawing seems to be inspired by the celebrated stanza of the poem in which Swinburne evokes the coming of spring and the presence in the spring landscape of Atalanta, the huntress of classical mythology:

When the hounds of spring are on
 winter's traces, ...
Come with bows bent and with emptying
 of quivers,

Maiden most perfect, lady of light,
With a noise of winds and many rivers,
With a clamour of waters and with might;
Bind on thy sandals, O thou most fleet,
Over the splendour and speed of thy feet...

Beardsley made a later drawing of this subject showing Atalanta accompanied by an actual hound.

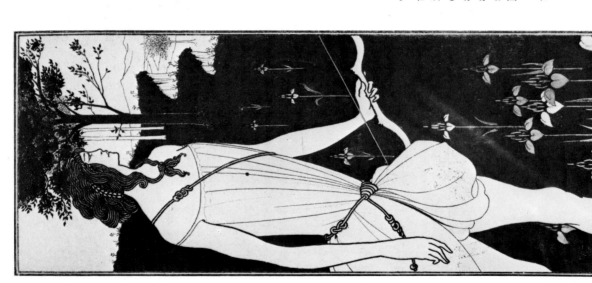

Fig. 34
Atalanta in Calydon

INK DRAWING, 30.5 × 11 CM. 1895. LONDON, THE
BRITISH MUSEUM

Volpone Adoring His Treasure

ILLUSTRATION TO *VOLPONE OR THE FOXE* BY BEN JONSON. INK DRAWING, 29 × 20.5 CM. 1897, PRINCETON UNIVERSITY LIBRARY

The ambitious project to illustrate Ben Jonson's play *Volpone or The Foxe* (first performed 1607) was conceived towards the end of 1897. By his death in March 1898 Beardsley had completed only the frontispiece and some initial letters. The frontispiece, showing Volpone gloating over his fraudulently obtained riches, is Beardsley's last great drawing and provides the evidence that he retained his powers to the last. In style it relates most closely to the illustrations for *The Rape of the Lock*. However the quality of the drawings is more solid and weighty than in the earlier works and appropriately, in view of the play's date, is inspired by the manner of seventeenth-century rather than eighteenth-century engraving. This drawing shows the distance Beardsley travelled from the medievalism of this early work. In December 1897 he wrote to Smithers about a new magazine they were thinking of starting to be called *The Peacock*: 'On the art side I suggest that it should attack *untiringly and unflinchingly* the Burne-Jones and Morrisian medieval business and set up a wholesome seventeenth- and eighteenth-century standard of what picture making should be.'

Ave Atque Vale was reproduced in the *The Savoy* No. 7, November 1896. It is an illustration to the poem *Carmen CI* (Song 101) by the Latin poet Catullus, of which Beardsley made his own translation. The title means 'hail and farewell'. Beardsley's translation and illustration of *Carmen CI* can perhaps be seen as a last explicit manifestation in his art of his awareness of approaching death:

> By ways remote and distant waters sped,
> Brother, to thy sad grave-side am I come,
> That I may give the last gifts to the dead,
> And vainly parley with thine ashes dumb:
> Since she who now bestows and now denies
> Hath ta'en thee, hapless brother, from mine eyes.

> But lo! these gifts, the heirlooms of past years,
> Are made sad things to grace thy coffin shell,
> Take them, all drenched with a brother's tears,
> And, brother, for all time, hail and farewell!

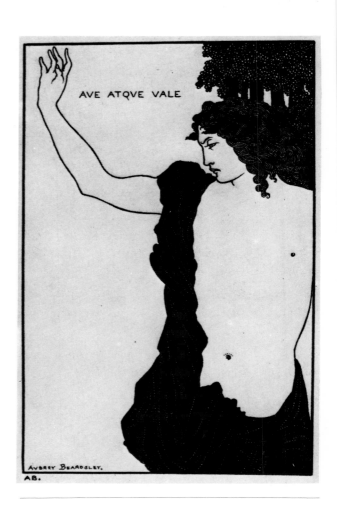

Fig. 35
Ave Atque Vale

INK DRAWING, 16 × 10.5 CM. 1896. NEW YORK, COURTESY OF MR JOHN HAY WHITNEY

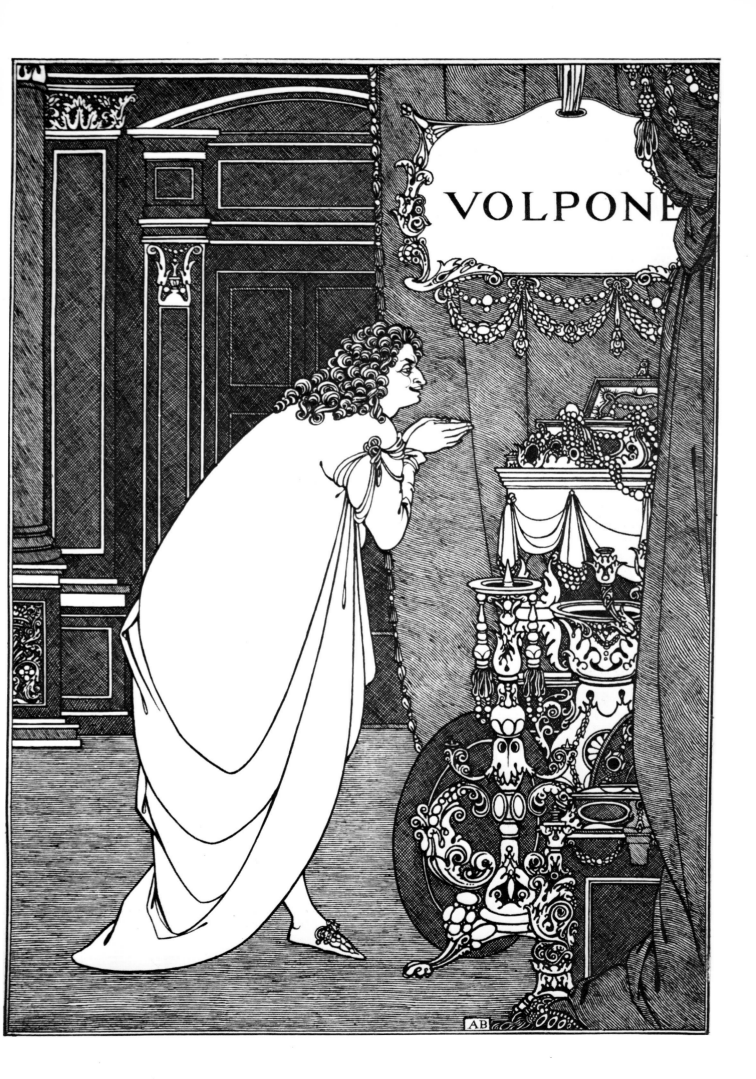